Pittsburgh
and the State of PENNSYLVANIA

It's hilly
with lots of bridges!
It's fun
with lots to do!

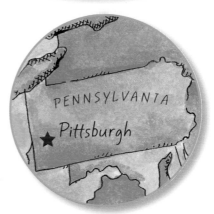

PENNSYLVANTA

Pittsburgh

The places where you live and visit help shape who you become. So find out all you can about the special places around you!

Cool Stuff™

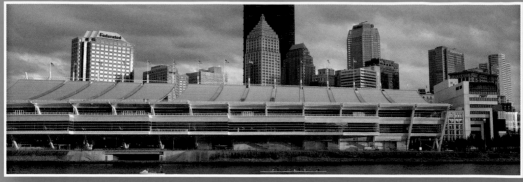

The David L. Lawrence Convention Center

CREDITS

Series Concept and Development

Kate Boehm Jerome

Design

Steve Curtis Design, Inc. (www.SCDchicago.com), Roger Radtke, Todd Nossek

Reviewers and Contributors

Lynne Glover, VisitPittsburgh; Connie Bodner, PhD., senior researcher;
Judy Elgin Jensen, research and production; Mary L. Heaton, copy editor

Photography

Cover(a), Back Cover(a), i(a), *By The Numbers* (a), xvi(c) © Alan Freed/Shutterstock; Cover(b), Back Cover(b), i(b) © Todd Taulman/Shutterstock; Cover(c, d), *By The Numbers* (c), *Sights and Sounds* (f), xvi(e) © Robert Pernell/Shutterstock; ii, *Sights and Sounds* (b), xvi(d) © Rhonda Marie Rose; iii, *Strange But True* (b), xvi(a) © trekandshoot/Shutterstock; *Spotlight* (background) © Filipe B. Varela/Shutterstock; *Spotlight* (a) © Chris Rokitski/Shutterstock; *Spotlight* (b) © Graphichead/Shutterstock; *By The Numbers* (b) © Pittsburgh Zoo & PPG Aquarium; *By The Numbers* (d) © sarent/iStockphoto; *Sights and Sounds* (a) © Jon Larson/iStockphoto; *Sights and Sounds* (c) © Marie C Fields/Shutterstock; *Sights and Sounds* (d) © Jerry Sharp/Shutterstock; *Sights and Sounds* (e) © Senator John Heinz History Center; *Sights and Sounds* (g) © Carnegie Science Center; *Strange But True* (a) *By* Sonal Shruti/Flickr/SonalS; *Strange But True* (c), xvi(f) © Jeffrey M. Frank/Shutterstock; *Marvelous Monikers* (a) © Tammy B. Clarke; *Marvelous Monikers* (b), xvi(h) © barbaradudzinska/Shutterstock; *Marvelous Monikers* (c) © Just Ducky Tours, Inc.; *Marvelous Monikers* (d) © Michelle Pennington; *Dramatic Days* (a) © Jonas Salk Polio Vaccine Collection, 1953-2005, UA.90.F89, University of Pittsburgh Archives; *Dramatic Days* (b) Pittsburgh Print Collection, c. 1843-1982, AIS.2006.03, Archives Service Center, University of Pittsburgh; *Dramatic Days* (c) From Wikimedia; xvi(b) © Wade H. Massie/Shutterstock; xvi(g) © Kristin Smith/Shutterstock

Illustration

i © Jennifer Thermes/Photodisc/Getty Images

ISBN 978-1-4396-0095-5

Library of Congress Catalog Card Number: 2010935889

Published by Arcadia Publishing, Charleston, SC

For all general information contact Arcadia Publishing at:
Telephone 843-853-2070
Fax 843-853-0044
Email sales@arcadiapublishing.com
For Customer Service and Orders:
Toll-Free 1-888-313-2665

Visit us on the Internet at www.arcadiapublishing.com

Table of Contents

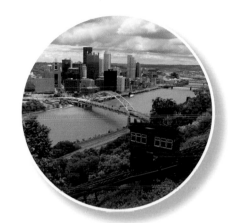

Pittsburgh

Pennsylvania

Spotlight on Pittsburgh!

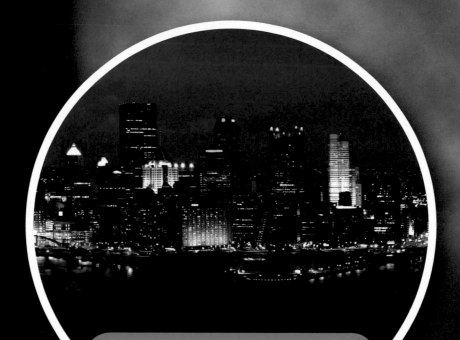

Pittsburgh is in the southwestern part of Pennsylvania. The city sits at the point where the Monongahela and Allegheny rivers join to form the Ohio River.

 How many people call Pittsburgh home? The population within the city limits is more than 310,000. But its county, Allegheny County, is home to more than 1,200,000 people.

 Are there any sports teams in Pittsburgh? Absolutely! Pittsburgh is a great sports town. Fans especially love to support the Steelers (football), the Pirates (baseball), and the Penguins (hockey).

 What's one thing every kid should know about Pittsburgh? The city was once a huge steel producer. But today the city's economy depends more on health care, education, tourism, technology, and financial services.

Visitors are invited to get wet at the Children's Museum of Pittsburgh. (Slickers and boots are provided at the Waterplay exhibit!)

Pittsburgh...

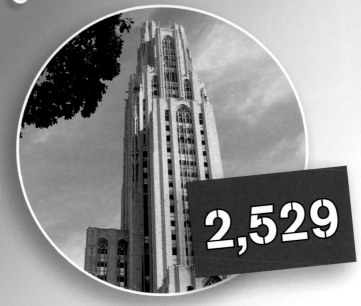

2,529

There are 2,529 windows in the University of Pittsburgh's Cathedral of Learning. This historic building (dedicated in 1937) stands 42 stories tall in the middle of Pitt's campus.

400

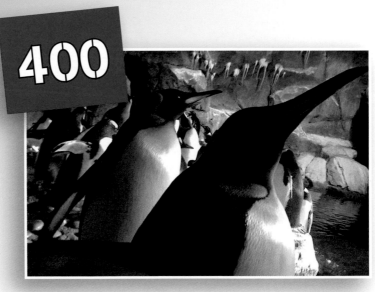

More than 400 different species of animals are represented at the Pittsburgh Zoo & PPG Aquarium. You can find three species of penguins there: the king, gentoo, and macaroni penguins!

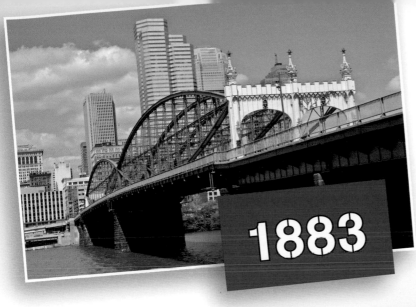

1883

The historic Smithfield Street Bridge, which crosses the Monongahela River, was opened in 1883. Since Pittsburgh has so many bridges it's known as—what else?—the City of Bridges.

Four separate museums make up the Carnegie Museums of Pittsburgh. They are the Carnegie Museum of Art, Carnegie Museum of Natural History, Carnegie Science Center, and the Andy Warhol Museum. (You can even tour a World War II-era submarine at the Science Center! The USS *Requin* first joined the fleet in 1945.)

4

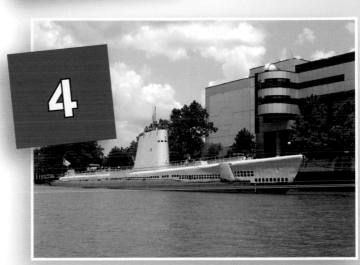

More Numbers!

841	Pittsburgh's tallest building, the U.S. Steel Tower, is 841 feet tall with 64 floors above ground.
1855	Andrew W. Mellon—a famous banker, art collector, and philanthropist—was born in Pittsburgh in 1855.
1974	Point State Park (at the tip of Pittsburgh's "Golden Triangle") was dedicated in 1974 and has been designated as a National Historic Landmark.

Pittsburgh: Sights and Sounds

Hear

...the huge sound of the Pittsburgh Symphony Orchestra and the lively music of the River City Brass Band. Both entertain large crowds throughout the year.

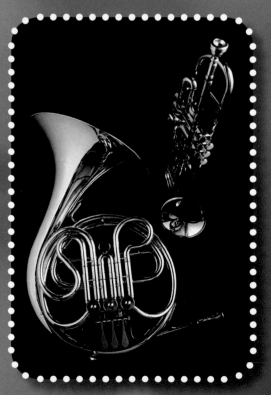

Smell

...the rich aromas in the Tropical Fruit and Spice Room at the Phipps Conservatory and Botanical Gardens.

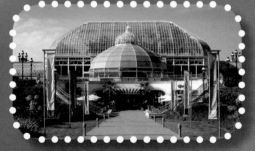

...the freshly baked bread and other great food in the historic market area of the Strip District.

See

…more than 600 birds at the National Aviary. You can get "up close and personal" with some of the birds. Have you ever fed a flamingo?

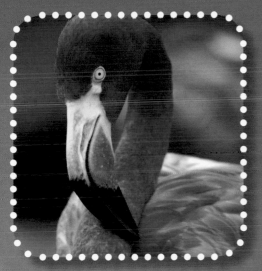

…the statues of famous Pittsburgh Pirates baseball players outside PNC Park. They honor Roberto Clemente, Willie Stargell, Bill Mazeroski, and Honus Wagner (who was nicknamed the Flying Dutchman.)

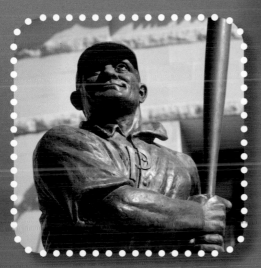

Explore

…all the interesting exhibits at the Heinz History Center. Named to honor Senator John Heinz, it's the largest history museum in Pennsylvania.

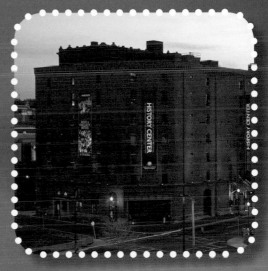

…how science and technology connect with everyday life at the Carnegie Science Center. (In the Kitchen Theater, you can learn about the science of food—then enjoy a taste test!)

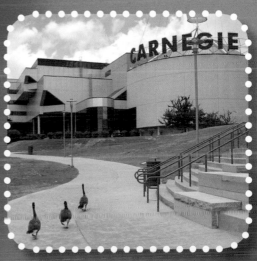

Sights and Sounds

STRANGE BUT TRUE!

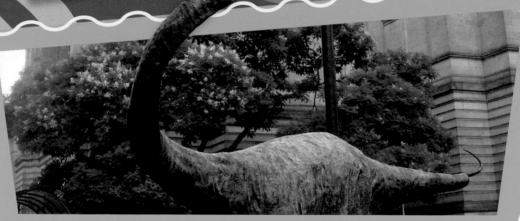

DISCOVERING DIPPY

In 1907 a doozy of a dinosaur skeleton was unveiled at the Carnegie Museum of Natural History. The 84-foot sauropod was named *Diplodocus carnegii* in honor of the museum's founder, Andrew Carnegie. It was later nicknamed Dippy.

Carnegie gave plaster casts of Dippy as gifts to other museums around the world, but the original Dippy still towers over visitors inside the Pittsburgh museum. (A life-size fiberglass Dippy also stands outside the museum.)

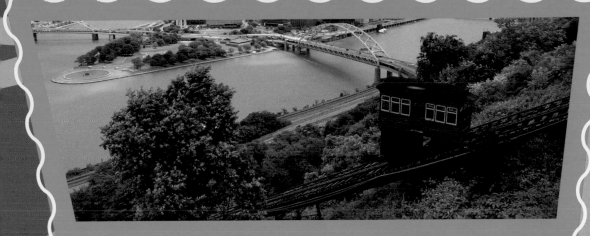

A STEEP SOLUTION

Because the hills around Pittsburgh are so steep, regular trains can't climb them. So cable railway systems, or inclines, were built to move material (and people!) up and down the slopes. The city once had many inclines, but today only two—the Monongahela and the Duquesne Inclines—are left.

KEEP THE "H"

In the late 1800s the United States Board of Geographic Names delivered a report to President Benjamin Harrison that recommended a change in spelling for all city and town names that were pronounced "berg." (Like Pittsburgh!) When President Harrison approved the report in December of 1891, Pittsburgh officially lost its "h." However, Pittsburgh city ordinances and council minutes continued to use the "h" until the Board finally reversed its decision in 1911—and Plttsburgh got its "official h" back!

Strange But True

Pittsburgh: Marvelous Monikers

What's a moniker? It's another word for a name...and Pittsburgh has plenty of interesting monikers around town!

Station Square

A Historic Hub

What was once a major hub for the Pittsburgh and Lake Erie Railroad has been turned into a 52-acre entertainment area called **Station Square**. In the heart of the square, the fountain at Bessemer Court provides a water show set to music!

Pierogies

A Tasty Name

Pittsburgh is known for its tasty **pierogies**—a dumpling of dough stuffed with many different fillings, from cheese and potato to sauerkraut.

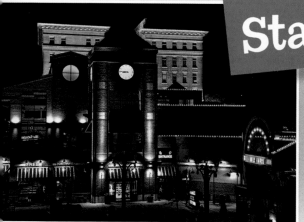

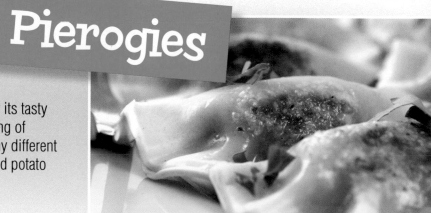

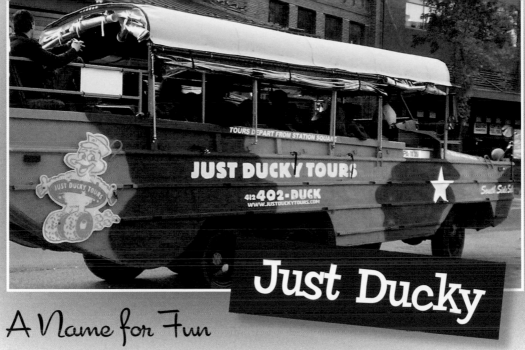

Just Ducky

A Name for Fun

You can see the city from many points of view on a **Just Ducky** tour. The vehicles travel on land—and in water!

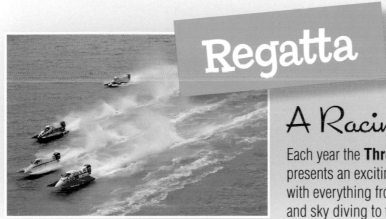

Regatta

A Racing Name

Each year the **Three Rivers Regatta** presents an exciting riverfront show, with everything from powerboat racing and sky diving to food and fireworks.

Pittsburghese

A Unique Name

Some people have a special way of talking in "da burgh" (Pittsburgh): *"Yinz gowen dahntahn?"* (Translation: "You going downtown?")

Pittsburgh: DRAMATIC DAYS

A HUGE Discovery!

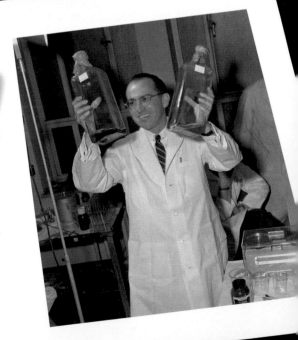

Polio was once a feared disease that could cause paralysis and death. However, in 1953 Dr. Jonas E. Salk, with the help of other researchers at the University of Pittsburgh, reported success with a vaccine that could fight the disease. His research (along with Dr. Albert Sabin's work a few years later) made polio a preventable disease for all of us.

A TRAGIC Fire!

On April 10, 1845 a fire broke out in Pittsburgh. Unfortunately, the weather had been dry and the wind was blowing that day so the fire quickly spread. 1,100 buildings were in ruins by the time the raging inferno was over. The fire even destroyed the covered bridge that crossed the Monongahela River.

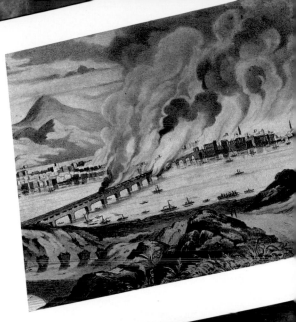

A GREAT Flood!

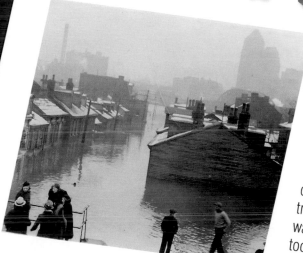

After a winter of heavy snow, the people of Pittsburgh were ready to celebrate on St. Patrick's Day in 1936. However, their plans soon changed. Water began pouring into the city the day before and continued throughout the night. By noon on St. Patrick's Day, boats had to be used on many of the streets, as cars and trolleys were underwater. Damage was severe but the flood planning that took place after the cleanup has made Pittsburgh a safer city to this day.

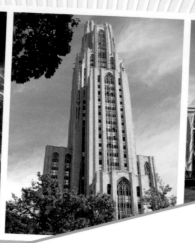

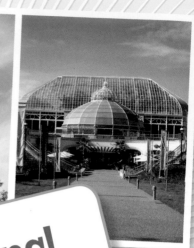

Congratulations!

You have just completed a kid-sized tour of Pittsburgh... but there's more to explore!

The city of Pittsburgh is an important part of the state of Pennsylvania. Why? It's because the city helps shape the state and the state helps shape the city!

Read on to find out more...

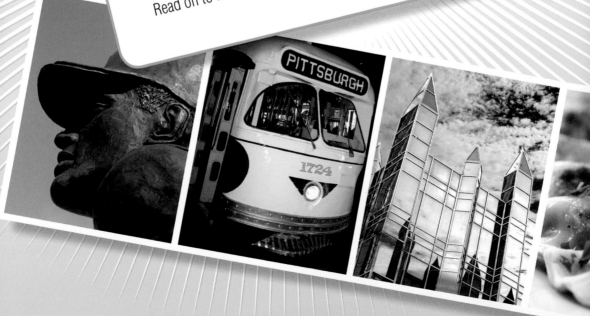

Pennsylvania

What's So Great About This State?

There is a lot to see and celebrate...just take a look!

CONTENTS

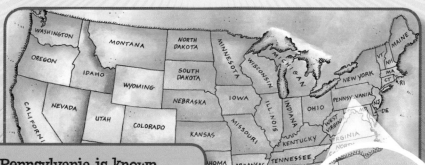

Pennsylvania is known as the birthplace of the nation. The Constitution and Declaration of Independence were both "penned," or written, here!

Well, how about...
the land!

From Lake Erie...

Pennsylvania is a rectangular-shape state located in the mid-Atlantic region of the United States. It is more than 44,000 square miles in size, and over half of this land is covered in beautiful forests!

From the low sandy beaches of Lake Erie to the high mountains of the Appalachians, Pennsylvania is loaded with interesting landforms. And what lies beneath the land's surface is just as amazing! Rich reserves of coal, oil, and natural gas have been found in many areas throughout the state.

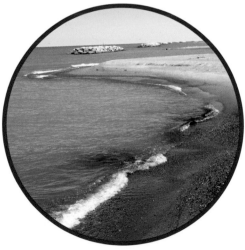

One of the many beaches found in Presque Isle State Park on the shores of Lake Erie in the northwestern part of the state.

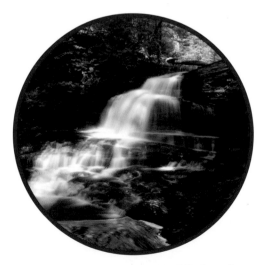

One of the many waterfalls found in Ricketts Glen State Park in the northeastern part of the state.

...to the Delaware River

Pennsylvania is also known for its rich soil. This means that farming is big. Wheat , corn, sweet cherries—lots of different crops are grown. But farms don't just grow plants. Pennsylvania is one of the leading producers of dairy products and meats so you can bet plenty of cows and chickens are raised there as well!

Pennsylvania has so many wonderful places! So take a closer look at the next few pages to get a "big picture" view—then decide which areas you might want to explore some more.

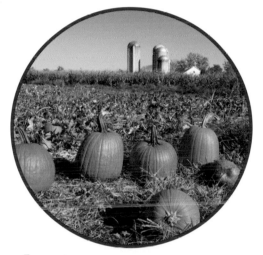

From wheat to pumpkins, the rich soil in Pennsylvania is good for growing many different crops.

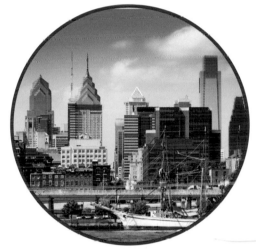

Philadelphia, the state's largest city, is in the southeastern part of the state.

Forests explode in color throughout Pennsylvania in the fall.

Plateaus, Ridges, and Valleys

ALLEGHENY PLATEAU

RIDGE AND VALLEY

The Allegheny National Forest is part of the
northern Allegheny Plateau region.

As you can see from the map, the *Allegheny Plateau* and the *Ridge and Valley* regions are big. In fact, the Allegheny Plateau includes more than half the land in the state!

What's so special about the plateaus and mountains?

If you could look at the state of Pennsylvania from a bird's-eye view, you would see that mountain ranges make a diagonal cut across the state. The Allegheny Mountains—part of the larger Appalachian Mountains—help form the western border of the Ridge and Valley region.

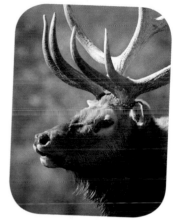

Forests in these regions provide habitats for a variety of plants and animals. And deep valleys have fertile soil for producing such crops as oats and hay.

The largest herd of elk in the eastern United States roams the Allegheny Plateau.

But that's not all!

Rich resources lie beneath the ground in many of these areas. The mining of coal, oil, and natural gas has played an important role in Pennsylvania's development. In fact, the first oil well in the United States was drilled in the Allegheny Plateau region—near Titusville in 1859.

What kinds of things can I see in these regions?

White-tailed deer roam through the thick forests. Brown bats surge from caves. It's amazing how many different types of plants and animals (including bears!) are in these Pennsylvania regions.

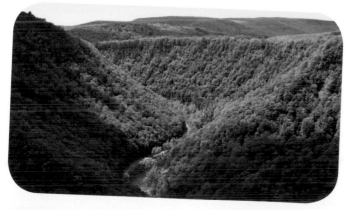

Did you know that Pennsylvania has its own "Grand Canyon?" Pine Creek Gorge has been named a National Natural Landmark. At its deepest point, the Gorge drops more than 1,000 feet.

5

Piedmont and Plains

ERIE
PLAIN

ATLANTIC
COASTAL
PLAIN

PIEDMONT

A typical Amish farm in the Piedmont area known
as Pennsylvania Dutch Country operates, or "runs,"
without using electricity or cars.

The lowest and flattest land in the state can be found in the two plains regions. The *Erie Plain* borders Lake Erie in the northwest. Kitty-corner from the Erie Plain, the *Atlantic Coastal Plain* lies in the southeast. Land begins to rise just west of the Atlantic Coastal Plain where the *Piedmont* region begins.

What's so special about these regions?

Plains are generally flat areas of land. That makes them good places to build cities. Erie is a large city in (of course!) the Erie Plain region. Philadelphia, the largest city in Pennsylvania, is in the Atlantic Coastal Plain.

The Piedmont region is known for having some of the best soil in the state. Farms with lots of crops and livestock dot the gently rolling hills in this area.

Where's the Pennsylvania Dutch Country? (...and how did it get its name?)

Pennsylvania Dutch Country is part of the Piedmont region in southeastern Pennsylvania. Many of the earliest settlers to this area in the late 17th and 18th centuries spoke German, or Deutsch. "Deutsch" eventually became "Dutch," but it refers to German heritage. This area is known for its local Amish and Mennonite populations who favor a more traditional lifestyle.

Wheat grown in the Piedmont can be made into flour—which can then be used to make delicious handmade pretzels!

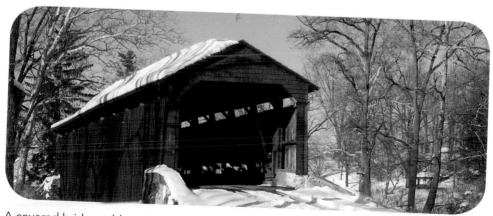

A covered bridge adds to winter's beauty in the Piedmont area of Pennsylvania.

Rivers and Lakes

This is a beautiful section of the west branch of the Susquehannah River around Hyner, Pennsylvania.

Pennsylvania is known for its thousands of miles of lovely creeks and rivers. Some are pretty long and big, too! The Delaware River forms the eastern border of the state. The Susquehanna River cuts through the mountains and zigzags through the interior part of the state. The Allegheny and Monongahela Rivers join at Pittsburgh to form the Ohio River.

Lake Erie forms about fifty miles of the state's border in northwestern Pennsylvania. But plenty of other smaller lakes can be found throughout the state.

Why are lakes and rivers so special?

The state's large rivers—along with Lake Erie—have helped make Pennsylvania an important trade and transportation center for centuries. They also provide recreation, food, drinking water, and habitats throughout the Keystone State.

By the way...why is Pennsylvania called the Keystone State, anyway?

No one knows for sure! But one theory has to do with how the land is situated. During colonial times Pennsylvania was the middle colony of the original thirteen. It had six states located above it and six states below it.

So some thought the state was like a keystone—the piece in the middle of a doorway or arch that holds everything together!

No matter where the nickname comes from, one thing is for sure. The Keystone State's lakes and rivers are some of the most beautiful in the United States.

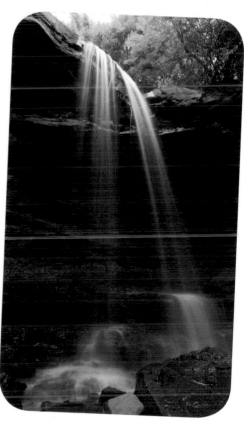

This is Cucumber Falls in the Ohiopyle State Park—which is located along the Youghiogheny River. If you want more action, you can go whitewater rafting along the lower and middle sections of the "Yough" (as the locals call it!).

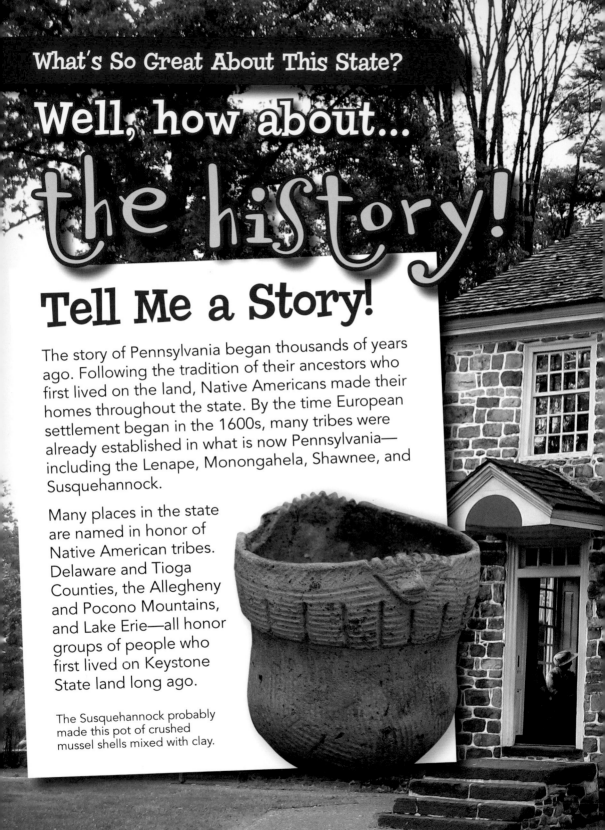

Well, how about...
the history!

Tell Me a Story!

The story of Pennsylvania began thousands of years ago. Following the tradition of their ancestors who first lived on the land, Native Americans made their homes throughout the state. By the time European settlement began in the 1600s, many tribes were already established in what is now Pennsylvania— including the Lenape, Monongahela, Shawnee, and Susquehannock.

Many places in the state are named in honor of Native American tribes. Delaware and Tioga Counties, the Allegheny and Pocono Mountains, and Lake Erie—all honor groups of people who first lived on Keystone State land long ago.

The Susquehannock probably made this pot of crushed mussel shells mixed with clay.

...The Story Continues

Eventually, Pennsylvania became home to many other groups, including Swedish, Dutch, and English explorers; European and American settlers; and African Americans. Many battles for independence were fought in Pennsylvania. In fact, Pennsylvania was one of the main battlegrounds during both the Revolutionary and Civil Wars.

But history isn't always about war. Many great educators, painters, writers, inventors, builders, and others have contributed to the state's history along the way. You can see evidence of this all over the Keystone State!

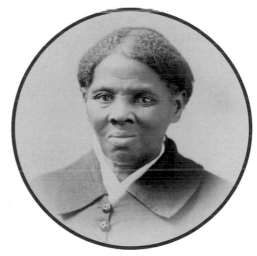

The United States Constitution was signed at the Constitutional Convention in Philadelphia, Pennsylvania, in 1787. The most famous Pennsylvania delegate to sign the Constitution was Benjamin Franklin.

In the 1840s, Harriet Tubman, an enslaved woman, escaped to Pennsylvania. She became a "conductor" on the Underground Railroad—helping hundreds of others escape from slavery to freedom in the North.

Monuments

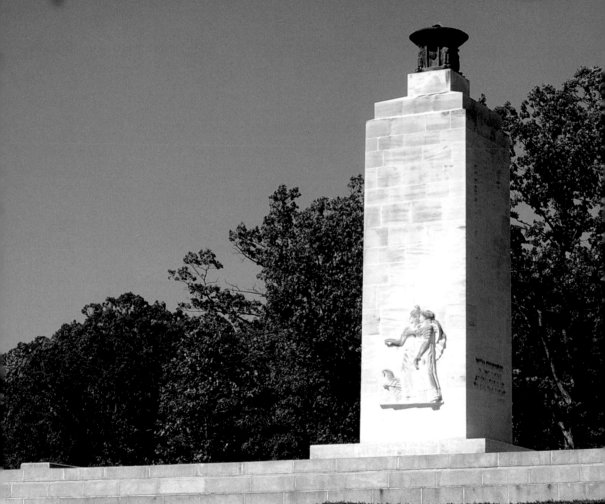

On July 3, 1938, former Union and Confederate soldiers met to dedicate the Eternal Light Peace Monument in Gettysburg National Military Park.

Monuments honor special people or events. Monuments also tell stories. The Gettysburg National Military Park has more than 1,400 monuments and markers that honor the soldiers of the Civil War, both Union and Confederate, who fought in the Battle of Gettysburg.

Why are Pennsylvania monuments so special?

They're special because they honor so many special people who helped build the Keystone State. Some were famous people. Others were just ordinary citizens who did extraordinary things to help shape both the state of Pennsylvania and the nation.

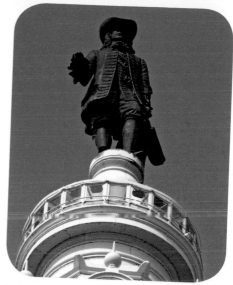

This statue on top of the Philadelphia City Hall honors the founder of Pennsylvania, William Penn.

Where are these monuments found?

Almost every town has found some way to honor a historic person or event with statues, plaques, named streets, or cornerstones. In fact, more than two thousand historical markers have been placed throughout the state to honor the memory of people, places, and events in Pennsylvania.

This bronze statue in Schenley Park in Pittsburgh honors the Allegheny County Medical Society Members who served in World War I.

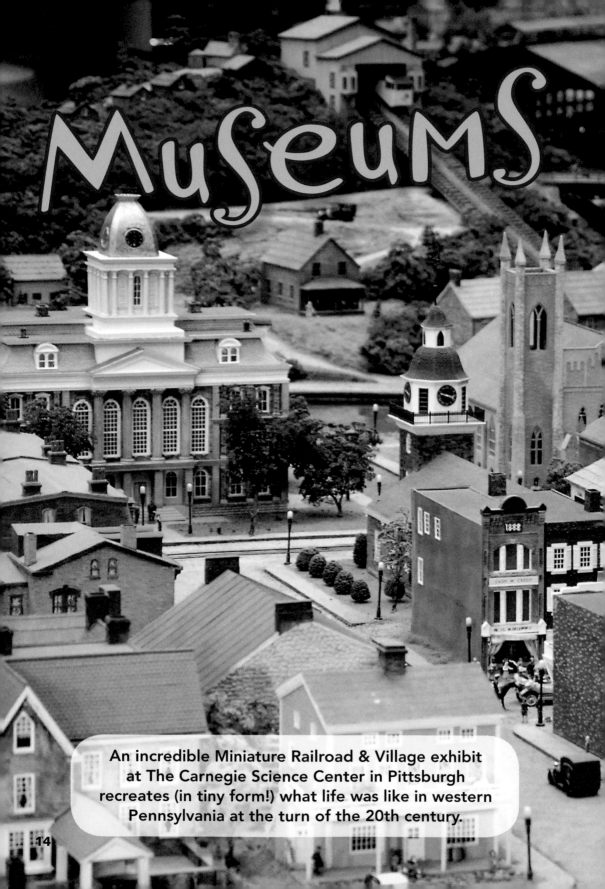

Museums

An incredible Miniature Railroad & Village exhibit at The Carnegie Science Center in Pittsburgh recreates (in tiny form!) what life was like in western Pennsylvania at the turn of the 20th century.

Museums don't just tell you about history—they make history come alive by showing you artifacts from times past. What's an artifact? It's any object that is actually produced by a human.

Why are Pennsylvania's museums so special?

Pennsylvania museums contain amazing exhibits with artifacts that tell many different stories. The Little League Baseball Museum in South Williamsport tells the story of how this sport grew from just thirty players in the 1930s to more than 2 million players today.

What can I see in a museum?

An easier question to answer might be, "What can't I see in a museum?" The State Museum of Pennsylvania—in the capital city of Harrisburg—has more than three million objects in its collections.

There are also plenty of hands-on exhibits in museums. For example, at the Carnegie Science Center in Pittsburgh, you can run, jump, climb, and test your reaction times as you learn about the physics of different sports!

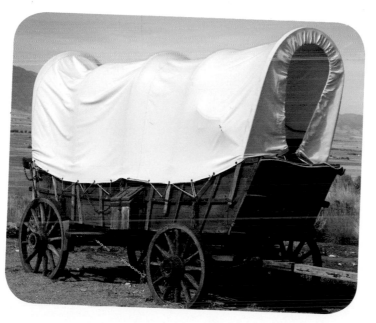

You can learn about Conestoga wagons like this one at the State Museum of Pennsylvania. First made near Lancaster, these wagons were the "big rigs" of the mid-eighteenth and early nineteenth centuries—except they were powered by a team of horses!

Forts

Fort Ligonier in Ligonier, Pennsylvania.

Long before the American colonists fought the British for their independence, the British clashed with the French for control of North America. Fort Ligonier was a British fort used in the mid-1700s. It is now restored and includes such sights as a blacksmith's shop, hospital, and soldier's barracks.

Why are forts special? (...and what is a fort, anyway?)

A fort is a place built for protection or defense. Forts were often built on high ground along an important transportation route. The inside of a fort was a self-contained community designed to survive long sieges, or battles. Barracks, storehouses, kitchens, and repair shops were built inside a fort. It had water and food supplies for the soldiers and sometimes for local people, too.

Besides Fort Ligonier, some of the other great forts in Pennsylvania's history include Fort Duquesne, Fort Necessity, and Fort Pitt. All of Pennsylvania's forts played important roles in the struggles of France, Great Britain, and the United States to win control of the land.

What can I see if I visit a fort?

Restored forts show you what life was like hundreds of years ago. You can see artifacts, including cannons and other weapons soldiers used. You can also see the places where the soldiers ate and slept. Sometimes there are re-enactments of battles.

...and there's more!

Even the forts that have mostly disappeared leave a footprint behind. Cities often build parks on these sites so people can sightsee and picnic.

Both Fort Duquesne and Fort Pitt once stood where three rivers (the Allegheny, Monongahela, and Ohio) come together. This area is now included in the city of Pittsburgh where Point State Park preserves the heritage of the forts.

Well, how about...
the people!

Enjoying the Outdoors

More than twelve million people claim the Keystone State as their home. So it should be no surprise that there are many different viewpoints throughout the state. Yet Pennsylvanians still have plenty in common.

Many share a love of the outdoors. Pennsylvania has four distinct seasons so the choices for activities change all year long. Camping and hiking in the fall, skiing and sledding in the winter, rafting and biking in the spring, and swimming and fishing in the summer—the list of activities that Pennsylvanians enjoy goes on and on!

Whitewater rapids bring kayakers to Ohiopyle State Park every spring.

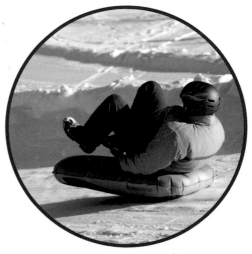

Ample snow makes for great "tube sledding" in winter.

Sharing Traditions

In the towns and cities throughout the state, Pennsylvanians share the freedom to celebrate different heritages. The great mix of cultures makes the state an interesting and exciting place to live.

Have you ever seen a beautiful Amish quilt? All of them are sewn by hand—it's a special skill passed down from generation to generation. Cooking is another way to pass on traditions. Have you ever tasted a Philadelphia cheesesteak? What about an Italian stromboli or maybe a Polish pierogi? These foods come from many cultures, but they are enjoyed at tables all over the state!

Making quilts is just one of many Amish traditions.

Pennsylvania apples make a great-tasting strudel.

Hikers can see beautiful leaf colors in the fall.

Protecting

In Philadelphia, the Schuylkill Center's Wildlife Rehabilitation Clinic cares for injured animals like this Great Horned Owl.

Protecting all of Pennsylvania's natural resources is a full-time job for many people!

Why is it important to protect Pennsylvania's natural resources?

The state of Pennsylvania is about 300 miles wide, so it has lots of different environments within its borders. The land changes across the state. From the Lake Erie shoreline to rolling hills and mountains—all of these different environments mean many different plants and animals can live throughout the state. In technical terms, Pennsylvania has great biodiversity! This biodiversity is important to protect because it keeps the environments balanced and healthy.

What kinds of organizations protect these resources?

It takes a lot of groups to cover it all. The U.S. Fish and Wildlife Service is a national organization. The Pennsylvania Department of Conservation and Natural Resources and the Pennsylvania Bureau of State Parks are state organizations. Of course, there are many other groups, such as the Audubon Society and the Rachel Carson Council, too.

And don't forget...

You can make a difference, too! It's called "environmental stewardship"—and it means you are willing to take personal responsibility to help protect Pennsylvania's natural resources.

The Pink Lady's Slipper orchid is a wildflower in Pennsylvania that is protected by the Private Wild Plant Sanctuary program.

Creating Jobs

Pennsylvania is a leading producer of eggs—
so even the chickens in the state work hard!

Pennsylvania grows more mushrooms than any other state.

Coal mining has been big in Pennsylvania since the mid-1700s. For many years coal was an important partner to Pennsylvania's steelmaking industry.

Military training is hard work!

Some jobs have been done in Pennsylvania for a long time. Farming is one of them. Other jobs, such as those in the high-tech and energy industries, are growing in demand.

What kinds of jobs are available throughout the state?

Agriculture is huge in Pennsylvania. Mushrooms, soybeans, corn, and oats are just some of the crops grown in the state. But farmers do more than grow plants. Raising livestock, such as cattle and chickens, is important, too.

The manufacturing of computer and electronic equipment is an expanding business in Pennsylvania. Energy industries are now providing jobs for many Pennsylvanians.

May I help you?

Another big industry is the service industry. Chefs, waiters, hotel clerks, and many other jobs are needed to help tourists sightsee, eat, and relax.

Don't forget the military!

The Air Force, Army, Coast Guard, and Navy all have a presence in the state. Pennsylvanians have a great respect for all the brave men and women who serve our country.

celebrating

Many people enjoy the Denver Fair in Lancaster County.

The people of Pennsylvania really know how to have fun! Instead of just one big state fair—they have over one hundred county fairs! More than five and one half million visitors attend these fairs that take place all over the state.

Why are Pennsylvania festivals and celebrations special?

Celebrations and festivals bring people together. From cooking contests to music festivals, events in every corner of the Keystone State showcase all different kinds of people and talents.

What kind of celebrations and festivals are held in Pennsylvania?

Too many to count! But one thing is for sure. You can find a celebration for just about anything you want to do.

Have you ever seen carving that's done with a chainsaw? Each year 25,000 people gather in Ridgway, Pennsylvania, to watch chainsaw carvers create amazing art.

Meyersdale, Pennsylvania, has one of the sweetest festivals in the state. Their Maple Syrup Festival has been going strong for more than sixty years.

...and don't forget the groundhog!

Each year the famous weather expert—Punxsutawney Phil—comes out of his burrow on February 2 (Groundhog Day) to predict how long wintry weather will last (but it's all in fun!).

You just might find a carving like this one at the Ridgway Rendezvous of chainsaw carvers.

You can take a hot-air balloon ride at the Keystone International Balloon Festival in Lancaster.

Birds and Words

What do all the people of Pennsylvania have in common? These symbols represent the state's shared history and natural resources.

State Bird
Ruffed Grouse

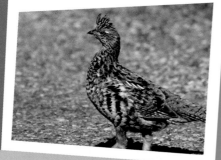

State Tree
Eastern Hemlock

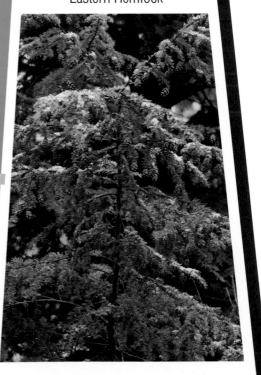

State Flower
Mountain Laurel

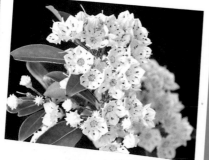

State Animal
White-tailed Deer

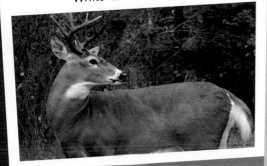

State Flag
Adopted June 13, 1907

State Insect
Firefly

Commonly called a "lightning bug," this little insect flashes its light on warm summer nights to attract a mate.

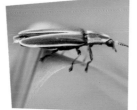

State Dog
Great Dane

State Fish
Brook Trout

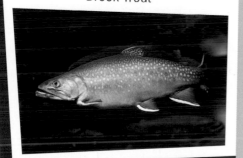

State Beverage
Milk

Want More?

Statehood—December 12, 1787
State Capital—Harrisburg
State Nickname—The Keystone State; The Quaker State
State Song—"Pennsylvania"

State Fossil—Trilobite
State Plant—Penngift Crownvetch
State Ship—U.S. Brig *Niagara*
State Motto—"Virtue, Liberty, and Independence"

More Fun Facts

More
Here's some more interesting stuff about Pennsylvania.

International Neighbor
The Great Lake of Erie separates part of the northern border of the state and Canada.

More Neighbors
New York, New Jersey, Delaware, Maryland, West Virginia, and Ohio all share borders with Pennsylvania.

Former National Capital
For ten of the early years in the country's history, **Philadelphia** served as the capital of the United States.

An Honored Father
Pennsylvania means "Penn's Woods." The name honors founder William Penn's father.

Revolutionary Tribute
A statue in **Carlisle** honors Mary Ludwig Hayes McCauley and all of the other women who helped their soldier husbands during the Revolutionary War. These women all got the same nickname—Molly Pitcher—because they carried water to the troops.

A Colorful Attraction
You can learn about the history of crayons at the Crayola Factory, the company's hands-on museum, in **Easton**.

A National Forest
The Allegheny National Forest was established in 1923. It's the only national forest in the state.

Internet Savvy
Back in 1999, Pennsylvania was the first state to list its official web site URL on license plates. (Now they use the tourism website: visitPA.com)

Electric City
In 1886, the nation's first electrified streetcar, or trolley, system was established in **Scranton**.

Pennsylvania Painter
Andrew Wyeth, one of the best known artists of the 20th century, was born in **Chadds Ford**, Pennsylvania.

Pocket Change
The United States Mint in **Philadelphia** produces lots of coins—between 11 and 20 billion each year!

A Tasty Honor
The town of **Hershey** is considered the chocolate capital of the United States. It is the nation's top chocolate producer.

The Fast Lane
The country's first multilane highway was the Pennsylvania Turnpike, which crosses the width of the state.

What's in a Name?
Bird-in-Hand and **Paradise** are just two of the places you can visit in Pennsylvania's Dutch Country.

Feels Like
Paul A. Siple grew up in **Erie** and became an Antarctic Explorer who helped develop (and coined the term) the "wind chill factor."

Top Banana
The city of **Latrobe** takes great pride in celebrating Dr. Dave Strickler's invention of the banana split in 1904.

Forever Cracked
The Liberty Bell (displayed in **Philadelphia**) cracked when it was first rung in 1752. It was recast twice…but cracked again. The bell rang for the last time to celebrate George Washington's birthday in 1846.

Hide the Bell
From the fall of 1777 to the winter of 1778, the Liberty Bell was hidden in a church in **Allentown** to keep it from the British Army.

The Quaker State
Pennsylvania earned this nickname because of the religion of its founder, William Penn, and the other Quakers who settled in the state.

Check It Out
The first lending library opened in **Philadelphia** in 1731.

Find Out More

There are many great websites that can give you more information about the exciting things that are going on in the state of Pennsylvania!

State Websites

The Official Government Website of Pennsylvania
www.pa.gov

Pennsylvania State Parks
www.dcnr.state.pa.us/stateparks

The Official Tourism Site of Pennsylvania
www.visitpa.com

Museums/Erie

The Erie Art Museum
www.erieartmuseum.org

Harrisburg

The State Museum of Pennsylvania
www.statemuseumpa.org

Hershey

The Hershey Story—The Museum on Chocolate Avenue
www.hersheystory.org

Philadelphia

The African American Museum in Philadelphia
www.aampmuseum.org

Philadelphia Museum of Art
www.philamuseum.org

Pittsburgh

Carnegie Museums of Pittsburgh
www.carnegiemuseums.org

Punxsutawney

Punxsutawney Weather Discovery Center
www.weatherdiscovery.org

Williamsport

Peter J. McGovern Little League Museum
www.littleleague.org/learn/museum.htm

Aquarium and Zoos

Pittsburgh Zoo & PPG Aquarium
www.pittsburghzoo.org

Philadelphia Zoo
www.philadelphiazoo.org

ZooAmerica—North American Wildlife Park (Hershey)
www.zooamerica.com

Pennsylvania: At A Glance

State Capital: Harrisburg

Pennsylvania Borders: New York, New Jersey, Delaware, Maryland, West Virginia, Ohio, and Lake Erie

Population: More than 12 million

Highest Point: Mount Davis, 3,213 feet above sea level

Lowest Point: Sea level at the Delaware River

Some Major Cities: Philadelphia, Pittsburgh, Allentown, Erie, Reading, Lancaster, Bethlehem, Scranton, Harrisburg, Wilkes-Barre, Hazelton

Some Famous Pennsylvanians

Louisa May Alcott (1832–1888) born in Germantown; was an American novelist best known for *Little Women*, a story based on the Alcott family.

Guion S. Bluford, Jr. (born 1942) from Philadelphia; is an astronaut who was the first African American to travel in space, on the *Challenger* in 1983.

James Buchanan (1791–1868) from Mercersburg; was the 15th President of the United States, from 1857–1861.

Rachel Carson (1907–1964) from Springdale; was a biologist and author who wrote about environmental issues. Her most famous book is *Silent Spring*.

Mary Cassatt (1844–1926) from Allegheny; was a painter and printmaker whose subjects often included mothers and their children.

Bill Cosby (born 1937) from Philadelphia; is a comedian, actor, author, television producer, educator, and activist.

Patti Labelle (born 1944) from Philadelphia; is a Grammy Award–winning rhythm and blues and soul singer.

Tara Lipinski (born 1982) from Philadelphia; is an athlete who won the Olympic gold medal in figure skating at the age of 15.

George C. Marshall (1880–1959) from Uniontown; was a five-star general, Chief of Staff of the Army, Secretary of State, Secretary of Defense, and Nobel Peace Prize winner.

Fred Rogers (1928–2003) from Latrobe; educator, minister, songwriter, and television host of the long-running children's program "Mister Rogers' Neighborhood."

Betsy Ross (1752–1836) lived in Philadelphia and was a seamstress who many think made the first American flag.

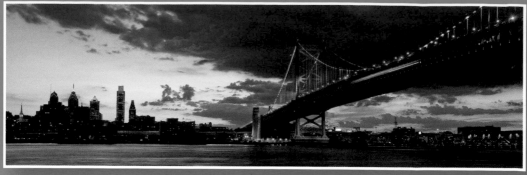

Benjamin Franklin Bridge over the Delaware River.

CREDITS

Series Concept and Development
Kate Boehm Jerome

Design
Steve Curtis Design, Inc. (www.SCDchicago.com); Roger Radtke, Todd Nossek

Reviewers and Contributors
Content review: Dr. Karen Guenther, Professor of History, Mansfield University; Contributing writers/editors: Terry B. Flohr; Stacey L. Klaman; Research and production: Judy Elgin Jensen; Copy editor: Mary L. Heaton

Photography
Back Cover(a), 26c © Andrew Williams/Shutterstock; Back Cover(b), 18a © Joy Fera/Shutterstock; Back Cover(c), 16-17 by Jeff Kubina; Back Cover(d), Cover(a), 4-5, Cover(d) © Jeffrey M. Frank/Shutterstock; Back Cover(e) by Elizabeth M. Lynch; Cover(b), 27(a) © Mike Rogal/Shutterstock; Cover(c), 6-7 © Dion Widrich/iStockphoto; Cover(e), 9 © Caleb Foster/Shutterstock; Cover(f) © Jonathan Smith/Shutterstock; 2-3, 18-19 © SNEHIT/Shutterstock; 2a © Caitlin Mirra/Shutterstock; 2b © Nathan Jaskowiak/Shutterstock; 3a, 7b © Delmas Lehman/Shutterstock; 3b, 27c © Andrea Gingerich/iStockphoto; 5a © Jason Lugo/iStockphoto; 5b © Curt Weinhold; 7a © PeJo/Shutterstock; 8-9 © Terry McCormick; 10-11 by Wally Gobetz; 10a Courtesy of The State Museum of Pennsylvania, Pennsylvania Historical and Museum Commission; 11a © Stephen Coburn/Shutterstock; 11b Courtesy of The Ohio Historical Society; 12-13 by Jen Goellnitz; 13a © K.L. Kohn/Shutterstock; 13b by Daderot/from Wikimedia; 14-15 by Patty Rogers, Miniature Railroad & Village®, Carnegie Science Center; 15 © Rita Robinson/iStockphoto; 17 © Steve Broer/Shutterstock; 18b © Marcel Jancovic/Shutterstock; 19a © Christina Richards/Shutterstock; 19b © Josef Bosak/Shutterstock; 20-21 Courtesy of The Schuylkill Center; 21 © Kirsanov/Shutterstock; 22-23 © Regina Chayer/Shutterstock; 23a © Chris leachman/Shutterstock; 23b © Lisa F. Young/Shutterstock; 23c © John Wollwerth/Shutterstock; 24-25 by Bob Jagendorf; 25a © fcarucci/Shutterstock; 25b © John Dorado/Shutterstock; 26a © Al Parker Photography/Shutterstock; 26b © hd connelly/Shutterstock; 27b © trubach/Shutterstock; 27d © Eric Isselée/Shutterstock; 27e © Eric Engbretson and U.S. Fish and Wildlife Service; 27f © HGalina/Shutterstock; 28 © Barbara Delgado/Shutterstock; 29a © BW Folsom/Shutterstock; 29b © JoLin/Shutterstock; 31 © R. Gino Santa Maria/Shutterstock; 32 © Steven Vona/Shutterstock

Illustration
Back Cover, 1, 4, 6 © Jennifer Thermes/Photodisc/Getty Images

ISBN 978-1-58973-021-2
Library of Congress Catalog Card Number: 2010935880

1 2 3 4 5 6 WPC 15 14 13 12 11 10

Published by Arcadia Publishing, Charleston, SC
For all general information contact Arcadia Publishing at:
Telephone 843-853-2070
Fax 843-853-0044
Email sales@arcadiapublishing.com
For Customer Service and Orders:
Toll Free 1-888-313-2665

Visit us on the Internet at www.arcadiapublishing.com

UNIVERSAL PUBLISHING

HANDWRITING

Book F

Writing in Cursive

Thomas M. Wasylyk

Copyright © 2006, All Rights Reserved

Book F - Item #137 - ISBN 978-1-931181-64-8

The Gettysburg Address

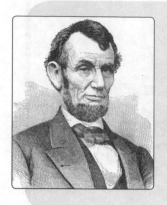

Fourscore and seven years ago our fathers brought forth on this continent, a new nation, conceived in Liberty, and dedicated to the proposition that all men are created equal.

Now we are engaged in a great civil war, testing whether that nation, or any nation so conceived and so dedicated, can long endure.

Abraham Lincoln

Write the sentences from the Gettysburg Address.

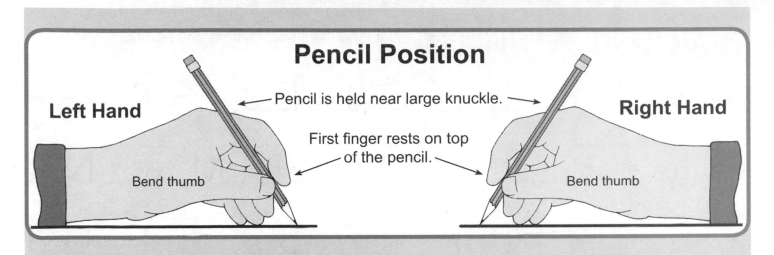

Pencil Position

Left Hand

← Pencil is held near large knuckle. →

First finger rests on top of the pencil.

Bend thumb

Right Hand

Bend thumb

GOOD POSTURE

1. Both feet on the floor
2. Elbows off the edge of desk
3. Sit back in chair
4. Shoulders slightly forward
5. Proper desk height

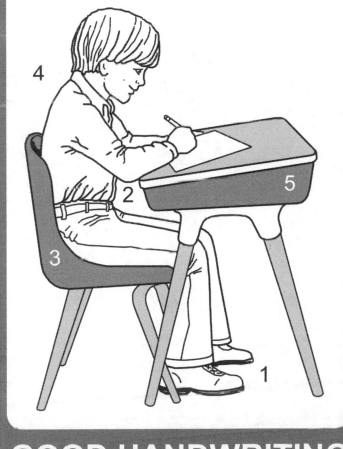

GOOD HANDWRITING

Paper Position for Cursive Writing

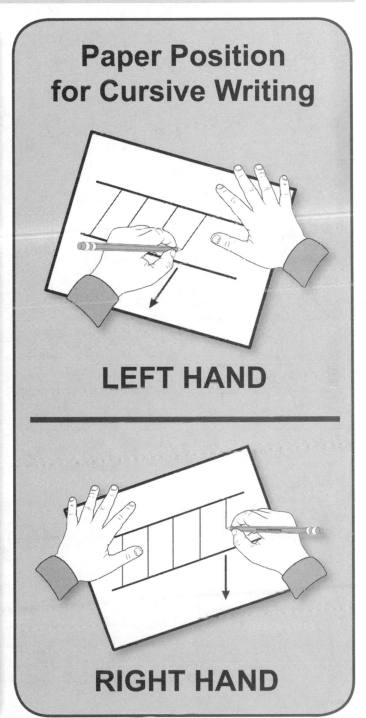

LEFT HAND

RIGHT HAND

Manuscript Alphabet

Write the manuscript letters and numbers.

A a B b C c D d E e F f G g

H h I i J j K k L l M m N n

O o P p Q q R r S s T t U u

V v W w X x Y y Z z . , ; : '

! ? " " () 1 2 3 4 5 6 7 8 9 10

Cursive Alphabet

Write the cursive letters and numbers.

A a B b C c D d E e F f

G g H h I i J j K k L l

M m N n O o P p Q q R r

S s T t U u V v W w X x

Y y Z z . , ; : ' ! ? " " ()

1 2 3 4 5 6 7 8 9 10

4

Size and Alignment

Size and alignment refer to the evenness of the letters along the baseline and along their tops, with all letters of the same size even in height.

Maximum-Size Letters - All uppercase letters, numbers, and the lowercase letters **b**, **f**, **h**, **k**, and **l** fill almost the full writing space.

A B C D E F G H I

1 2 3 4 5 b f h k l

Maximum Size Letters

Minimum-Size Letters - Letters that fill approximately one-half of the writing space.

a c e g i j m n o p q

r s u v w x y z

Descender Letters

Letters with lower loops that fill approximately one-half of the space below the baseline.

f g j p q y z y z

Intermediate Letters - The lowercase letters **d** and **t** fill approximately two-thirds of the writing space.

d t

Write the sentences.

Handwriting is a vehicle that carries a message to the reader. If the handwriting is illegible the message will never reach its destination. If what you write must be read by others, it must be written legibly.

Cursive Basic Strokes

little

Slant Strokes - The slant stroke is used in many cursive letters. Can you name the letters that contain a slant stroke?

Trace and write the slant strokes.

Study the slant strokes in the letters to the right.

l b a h i H f K

Undercurve - The undercurve is used to begin fourteen lowercase letters. Can you name them?
Trace and write the undercurves.

Study the undercurves in the letters to the right.

b c f i r s t B P

Downcurve - The downcurve is used in six lowercase letters. Can you name them?
Trace and write the downcurves.

Study the downcurves in the letters to the right.

a d g q o c A

Overcurve - The overcurve is used to begin six lowercase letters. Can you name them?
Trace and write the overcurves.

Study the overcurves in the letters to the right.

m n v x y z Y

Write the words **letter**, **added**, and **minimum**. Check your basic strokes.

Cursive Basic Strokes

Your hand and arm should move together when doing the exercises below. Don't just use your fingers when you write. Try to develop good hand/arm movement.

Trace and write the undercurve-slant exercise.

Trace and write the overcurve-slant exercise.

Trace and write the undercurve-loop-slant exercise.

Matching - Draw a line from each stroke to the correct name.

- **OVERCURVE**

- **SLANT**

- **UNDERCURVE**

- **DOWNCURVE**

Match the **beginning** strokes to the correct letter.

Match the **ending** strokes to the correct letter.

7

Line Quality

Line quality refers to the smoothness, evenness, color, and thickness of the pencil line.

Be sure to apply the correct amount of pressure on your pencil. Too much pressure will make your writing too dark. Not enough pressure will make it too light. Uneven pressure will make it vary.

CORRECT	TOO HEAVY	TOO LIGHT	VARYING
blue	*blue*	*blue*	*blue*

Letter Forms

All letter forms are made up from the basic strokes. If you make your basic strokes correctly, your writing will be legible.

Study the basic strokes below. Pay close attention to how they are used in the letter forms.
Make your **undercurves** wide.

Do not undercurve up too soon.

Write the undercurve letters **i**, **t**, **u**, **e**, **l**, **b**, **f**, **h**, and **k**. Be sure your undercurves are wide.

Make the **downcurves** wide in the letters **a**, **d**, **g**, and **q**.

Downcurves are too sharp, should be wide.

Make sharp downcurves in **o** and **c**.

Write the downcurve letters **a**, **d**, **g**, **q**, **A**, **o**, and **c**. Be sure your downcurves are correct.

Make your **overcurves** wide.

Do not overcurve up too quickly.

Write the overcurve letters **m**, **n**, **v**, **x**, **y**, and **z**. Be sure your overcurves are correct.

Pencil Position

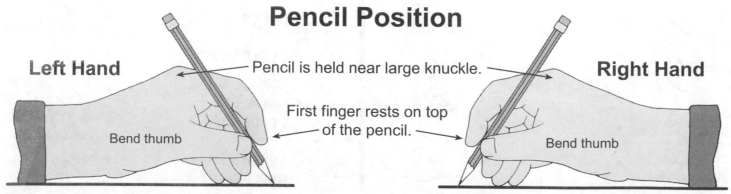

Left Hand

Pencil is held near large knuckle.

First finger rests on top of the pencil.

Bend thumb

Right Hand

Bend thumb

8

Spacing

Correct spacing between letters, words, and sentences makes your writing easy to read. Study the spacing examples below.

Spacing between Letters and Words - Allow enough space between words for a small oval. The sentence below shows correct spacing between letters and words.

This sentence has good spacing between the letters and words.

Write the sentence. Check your spacing between letters and words.

I saw the first star tonight.

Spacing between Sentences - Allow enough space between sentences for a large oval. The example below shows correct spacing between sentences.

Pat plays soccer. Olivia plays baseball. They also like to sing.

Write the sentences. Check your spacing between sentences.

Val is my sister. She is great!

New Paragraph Indent - When you indent for a new paragraph, allow enough space for two large ovals. Study the example below.

The second week of volleyball practice was great. I had the . . .

Write the sentences. Check your spacing between letters, words, and sentences.

**I like to play softball. I play third base. My team
and I have fun when we practice for a big game.**

 CHECK-UP ❑ SLANT OF WRITING ❑ WORD SPACING ❑ LETTER FORMS ❑ JOININGS

Be sure to close the downcurve-undercurve motion. Pull the slant stroke to the baseline before you undercurve. Trace and write the letter.

1. Downcurve
2. Undercurve
3. Slant
4. Undercurve

Trace and write the joinings and words.

Ad	Adam	Ar	Arctic	Am	Amy

Write the sentences. Check your writing.

There are seven continents. They are North America, South America, Europe, Africa, Asia, Australia, and Antarctica. Australia is the smallest continent and the only continent that is also a country. Asia is the largest continent.

Begin this letter with a wide downcurve. Pull the slant stroke to the baseline before you make the undercurve ending. Trace and write the letter.

1. Downcurve
2. Undercurve
3. Slant
4. Undercurve

a *a* *a*

a *a* *a*

a

Trace and write the joinings and words.

ap	*apricot*	*ad*	*adopt*	*an*	*angle*
ap	*apricot*	*ad*	*adopt*	*an*	*angle*

Write the sentences. Check your writing.

Antarctica is the southernmost

continent. In 1840 Charles Wilkes,

an American explorer, declared

it a continent. In 1911, Norwegian

explorer Roald Amundsen became

the first man to reach the South

Pole at the center of Antarctica.

Keep the top and bottom sections of this letter the same size. The loop is made on the dotted line. Trace and write the letter.

B B B
B B B
B

1. Undercurve
2. Slant
3. Curve forward
4. Curve forward
5. Swing right

Trace and write the words.

Barbara	Boston	Byron	Belgium
Barbara	Boston	Byron	Belgium

Write the sentences. Check your writing.

Baltimore is located in Maryland
on the Chesapeake Bay. It is
named after Cecil Calvert, whose
title was "Lord Baltimore."
Baltimore is one of the busiest
ports in the United States and
was once a ship-building center.

Begin with a wide undercurve. Be sure to keep the loop open. Pull the slant stroke to the baseline, then make a sharp undercurve. Trace and write the letter.

b *b* *b*

b *b* *b*

b *b*

1. Undercurve
2. Slant
3. Undercurve
4. Swing right

Trace and write the joinings and words.

bl	*blank*	*bo*	*bolt*	*be*	*beach*
bl	*blank*	*bo*	*bolt*	*be*	*beach*

Write the sentences. Check your writing.

Babe Ruth, the famous baseball player, was born in Baltimore and began his professional career with the Baltimore Orioles. He then went on to play for the Boston Red Sox, the New York Yankees, and the Boston Braves.

1. Short slant
2. Downcurve
3. Undercurve

Begin with a short slant stroke. Think of a backward-oval motion as you write this letter. Trace and write the letter.

C C C C

C C C C

C

Trace and write the joinings and words.

Co	Congo	Cy	Cynthia	Ch	Charles
Co	Congo	Cy	Cynthia	Ch	Charles

Write the sentences. Check your writing.

Coniferous trees grow cones and are

usually evergreen. They include

spruces, firs, cedars, and pines.

The redwood is a species of conifer

that grows along the west coast

of the United States, in California

and Oregon.

✔ **CHECK-UP** ❑ LINE QUALITY ❑ LETTER SPACING ❑ SIZE OF WRITING ❑ LETTER FORMS

14

This letter also begins with a short slant stroke. The undercurve ending is made wide; do not force it up too quickly. Trace and write the letter.

C

1. Short slant
2. Sharp downcurve
3. Undercurve

Trace and write the joinings and words.

cr	crane	co	courage	ca	cartons

Write the sentences. Check your writing.

Cones from the conifers contain seeds that are collected by birds and animals for food. Some of the seeds plant themselves and grow into trees. The cones are also used by many people to make holiday decorations.

Writing Cursive Numbers

Trace and write the numbers.

1 1 1
2 2 2
3 3 3
4 4 4
5 5 5
6 6 6
7 7 7
8 8 8
9 9 9
10 10 10

Write the numbers from *largest* to *smallest*.

62,645 _____
5,084 _____
71,921 _____
3,875 _____
35.20 _____
85.93 _____
103,567 _____
489 _____
85.25 _____
85.90 _____

Write the numbers from *smallest* to *largest*.

3,983 _____
752,217 _____
410 _____
3,166 _____
65 _____
78,036 _____
904 _____
53 _____
751,351 _____
61,938 _____

Calculating Numbers

12 inches = 1 foot
3 feet = 1 yard
5,280 feet = 1 mile

How many inches
in one mile?

How many inches
in 100 yards?

Using the Correct Word

Write the correct word to complete each sentence.

Carley liked every book (**accept except**) the last one.

Jacob would be glad to (**accept except**) the job.

It is commonly known that heat (**raises rises**).

We will try to (**raise rise**) money for the trip.

The snow-covered trees were a beautiful (**sight site**).

The construction (**sight site**) has been closed.

Please (**sit set**) the packages on the table.

Would you like to (**sit set**) in the living room?

Lila's shirt (**compliments complements**) her eyes.

Ira (**complimented complemented**) Tina's haircut.

Kevin is going to (**lie lay**) down and take a nap.

Tell Ellen to (**lie lay**) her clothes in the drawer.

$$ Making Good Cents $$

You just told someone you would work for them for "double a penny a day."
(First day you get paid 1 penny, second day 2 cents, third day 4 cents, fourth day 8 cents, etc.)

How much money would you make in 5 days?

How much money would you make in 10 days?

How much money would you make in 15 days?

How much money would you make in 20 days?

How much money would you make in 25 days?

How much money would you make in 30 days?

D

1. Slant
2. Loop
3. Curve up
4. Loop

Begin this letter with a slant stroke that loops at the baseline. Keep the letter open and rounded. Trace and write the letter.

D D D D

D D D D

D

Trace and write the words.

Dundee	Detroit	Dashawn	Doreen
Dundee	Detroit	Dashawn	Doreen

Write the sentences. Check your writing.

Dobermans, dalmations, dachshunds,

and dingoes are different breeds

of dogs. Dobermans are large dogs

with dark hair. Dalmations are

white dogs with black dots.

Dachshunds are small dogs with

long bodies and short legs.

1. Downcurve
2. Undercurve
3. Slant
4. Undercurve

d d d *d*

d d *d*

d

Trace and write the joinings and words.

de	*dentist*	*di*	*disc*	*dd*	*addition*
de	*dentist*	*di*	*disc*	*dd*	*addition*

Write the sentences. Check your writing.

Dingoes are wild dogs

that live in Australia.

Dobermans, dalmations,

and dachshunds are all domestic

dogs. That means that they are

tame and usually live

with people as a pet.

DINGOES

DOBERMAN

Keep the two sections of this letter well rounded. The top section is slightly smaller. The loop occurs just above the dotted line. Trace and write the letter.

\mathcal{E} \mathcal{E} \mathcal{E}

\mathcal{E} \mathcal{E} \mathcal{E}

\mathcal{E} \mathcal{E}

1. Short slant
2. Curve back
3. Curve back, undercurve

Trace and write the joinings and words.

$\mathcal{E}v$	$\mathcal{E}van$	$\mathcal{E}c$	$\mathcal{E}cuador$	$\mathcal{E}l$	$\mathcal{E}liana$
$\mathcal{E}v$	$\mathcal{E}van$	$\mathcal{E}c$	$\mathcal{E}cuador$	$\mathcal{E}l$	$\mathcal{E}liana$

Write the sentences. Check your writing.

Mount Everest is the highest

mountain in the world. It is

located between Nepal and Tibet

and is over 29,000 feet high. In

1953, Edmund Hillary of New

Zealand became the first person to

reach the top of Mount Everest.

The undercurve beginning must be low and wide to allow room for the loop. Pull the slant stroke to the baseline. Trace and write the letter.

1. Undercurve, curve back
2. Slant
3. Undercurve

e *e* *e*
e *e* *e*
e

Trace and write the joinings and words.

er	*erased*	*ev*	*evenly*	*ea*	*easel*
er	*erased*	*ev*	*evenly*	*ea*	*easel*

Write the sentences. Check your writing.

The Articles of Confederation were

the first constitution of the United

States of America. They were

adopted by the Continental Congress

in 1777 and ratified in 1781.

The Articles were replaced by the

United States Constitution in 1789.

Begin this letter with a slant to the baseline. Then curve up, retrace, swing right, and slant. Finish with a double curve. Trace and write the letter.

1. Slant, curve up
2. Swing right
3. Slant
4. Curve up, down, and up

\mathcal{F} \mathcal{F} \mathcal{F}

\mathcal{F} \mathcal{F} \mathcal{F}

\mathcal{F}

Trace and write the words.

| Farley | Florida | Finland | Fern |
| Farley | Florida | Finland | Fern |

Write the sentences. Check your writing.

The French and Indian War took

place in North America from

1754–1763. The war was between

Great Britain and France. It is

called the French and Indian War

because the Algonquin and Huron

Indians were allies to France.

Be sure the beginning undercurve is made wide. Keep the upper and lower loops open and the same size. Trace and write the letter.

1. Undercurve
2. Slant
3. Curve up, tie
4. Undercurve

Trace and write the joinings and words.

fa	fawn	fi	fiber	fo	fountain

Write the sentences. Check your writing.

Forests are full of fascinating things. There are many different types of plants and animals. Plants that prefer shade grow profusely in forests.

What does the word "profuse" mean?

Study the upper loops in the letters below. Trace and write the letters. Write the words.

b *b* *bubbles*

f *f* *fifty*

h *h* *held*

k *k* *kicked*

l *l* *labels*

Trace and write the joinings. Write the words.

bb *bb* *lobby*

fl *fl* *flash*

bl *bl* *block*

ll *ll* *mall*

lk *lk* *silk*

ff *ff* *scuff*

Write the sentence below. Check your writing.

Keep the upper loops open in the letters b, f, h, k, and l.

Keep upper loops open.

b f h k l

Pencil Position

Left Hand Pencil is held near large knuckle. **Right Hand**

First finger rests on top of the pencil.

Bend thumb

Bend thumb

Write the sentences.

Patrick Henry was born in Virginia in 1736 and lived there until his death in 1799. He was a leader in the American Revolution, fighting to free the American colonies from British rule. He served three terms as governor of Virginia, and is perhaps best remembered for the speech in which he proclaimed, "Give me liberty or give me death!"

Begin this letter with a wide undercurve. The big loop crosses just above the dotted line. Keep the letter open. Trace and write the letter.

G *G* *G*

G *G* *G*

G *G*

1. Undercurve, curve back
2. Curve down, up
3. Slant, curve up
4. Swing right

Trace and write the words.

Grenada	Georgia	Glen	Gabriela
Grenada	Georgia	Glen	Gabriela

Write the sentences. Check your writing.

Giraffes live in Africa. They are

the tallest animals in the world.

Giraffes have very long necks

and long legs. A giraffe's head

might be as high as eighteen

feet off the ground. Giraffes

eat grass and leaves.

Be sure to close the downcurve-undercurve motion. The overcurve ending crosses the slant stroke at the baseline. Trace and write the letter.

1. Downcurve
2. Undercurve
3. Slant
4. Overcurve

Trace and write the joinings and words.

gr	gravity	ga	gaped	gl	glimpse

Write the sentence: **Greg asked Peggy to put the gas grill and garden hose in the garage.**

Cursive Paper Position

The position of your paper or book is important for maintaining consistent slant in your writing. It also helps with the overall legibility of your handwriting.

Left Hand

Right Hand

Pencil Position

Left Hand

Pencil is held near large knuckle.

Right Hand

First finger rests on top of the pencil.

Bend thumb

Bend thumb

Be sure the two slant strokes in this letter are parallel. The loop touches the dotted line and then swings down and up. Trace and write the letter.

1. Overcurve, slant
2. Slant
3. Curve back
4. Curve down

Trace and write the joinings and words.

Ha	Hartford	He	Heidi	Ho	Howie

Write the sentences. Check your writing.

The Hawaiian Islands are a group
of islands in the North Pacific
Ocean. The largest of the islands
is the island of Hawaii. Hawaii's
capital is Honolulu. The Hawaiian
Islands became a part of the
United States in 1959.

Begin with a wide undercurve to allow room for the loop. Keep the loop open. Keep the two slant strokes in this letter parallel. Trace and write the letter.

h

1. Undercurve
2. Slant
3. Overcurve
4. Slant
5. Undercurve

h h _____ h

h h _____ h

h _____ h

Trace and write the joinings and words.

ha	hangar	ho	hood	he	herb
ha	hangar	ho	hood	he	herb

Write the sentences. Check your writing.

The state flower of
Hawaii is the hibiscus
and the state bird is called the
Nene or the Hawaiian goose. Hawaii
is known as the Aloha State.
Aloha is a Hawaiian word that
means hello or goodbye.

Hawaii
Hibiscus

✔ **CHECK-UP** ❑ SLANT OF WRITING ❑ WORD SPACING ❑ LETTER FORMS ❑ JOININGS

The letter starts below the baseline. The curve up and curve down forms the loop. Keep the loop open. The loop should have good slant. Trace and write the letter.

1. Curve up
2. Curve down, curve up
3. Swing right

Trace and write the words.

Idaho	Isabella	Irving	Iowa

Write the sentences. Check your writing.

Iowa, Illinois, and Indiana are

states located in the central U. S.

In 1816 Indiana was

the first of the three to

become a state, followed

by Illinois in 1818

and Iowa in 1846.

INDIANA
Indianapolis

Chicago

ILLINOIS
Springfield

IOWA
Des Moines

Begin this letter with a wide undercurve. Be sure to pause at the top of the letter. Pull the slant stroke to the baseline. Trace and write the letter.

1. Undercurve
2. Slant
3. Undercurve
4. Dot

i *i* *i* *i*
i *i* *i*
i

Trace and write the joinings and words.

ir	*irrigate*	*in*	*index*	*ig*	*igloo*
ir	*irrigate*	*in*	*index*	*ig*	*igloo*

Write the sentences. Check your writing.

King Philip's War took place from

1675 to 1676. It was between the

New England colonists and the

Wampanoag Indians. This war

was named for King Philip, chief

of the Wampanoag Indians. His

Indian name was Metacom.

Checkstroke Joinings

The stroke used to join two letters greatly affects the legibility of your writing.

Checkstroke to Undercurve

ve bl os

1. Pause as you complete the first letter (top arrows).
2. Retrace and swing right as needed to properly form the next letter (bottom arrows).

The checkstroke-ending letters (**b**, **v**, **o**, and **w**) join to the undercurve letters **b**, **e**, **f**, **h**, **i**, **j**, **k**, **l**, **p**, **r**, **s**, **t**, **u**, and **w** as shown in the examples in the box. Trace and write the joinings. Write the words.

ve	ve	vest
bl	bl	able
os	os	loss
wi	wi	with

Checkstroke to Downcurve

ba vo

1. Pause as you complete the first letter (see first arrow on each joining above).
2. Retrace and swing right forming the top part of the next letter (see second arrow on each joining above).

The checkstroke-ending letters (**b**, **v**, **o**, and **w**) join to the downcurve letters **a**, **d**, **g**, **q**, **o**, and **c** as shown in the examples in the box. Trace and write the checkstroke-to-downcurve joinings. Write the words.

wo	wo	two
ba	ba	bat
vo	vo	vote
oo	oo	took

Checkstroke to Overcurve

oy by on

1. Pause as you complete the first letter (see first arrow on each joining above).
2. Retrace and swing right forming the top part of the next letter (see second arrow on each joining above).

The checkstroke-ending letters (**b**, **v**, **o**, and **w**) join to the overcurve letters **m**, **n**, **v**, **x**, **y**, and **z** as shown in the examples in the box. Trace and write the checkstroke-to-overcurve joinings. Write the words.

oy	oy	joy
on	on	bone
by	by	bye
vy	vy	ivy

Write the sentence.

The cursive letters b, v, o, and w

are checkstroke-ending letters.

Trace and write the joinings. Write the words.
Check your joinings.

br br	brown
be be	become
bs bs	bulbs
ve ve	valve
vo vo	voice
vy vy	envy
vi vi	vivid
oo oo	cooled
of of	offered
om om	some
or or	color
wa wa	waste
wh wh	wheel
wo wo	world

Write the sentence. Are all of your checkstroke joinings correct?

Nicole and Edward waved as they

drove by Gabe's new house.

Pencil Position

Left Hand

Pencil is held near large knuckle.

First finger rests on top
of the pencil.

Bend thumb

Right Hand

Bend thumb

Keep both loops open in this letter. The slant stroke is pulled below the baseline. All three strokes cross at the baseline. Trace and write the letter.

1. Curve up
2. Slant
3. Overcurve

Trace and write the joinings and words.

Je	Jeremy	Jo	Josie	Ju	Jupiter

Write the sentences. Check your writing.

Thomas Jefferson was the third President of the United States. He wrote the Declaration of Independence. Jefferson also founded the University of Virginia and was the person responsible for the Louisiana Purchase.

Pause after the undercurve, then slant. Be sure your book is in the correct position for cursive writing. Trace and write the letter.

1. Undercurve
2. Slant
3. Overcurve
4. Dot

Trace and write the joinings and words.

jo	jogged	ju	junior	je	jewelry

Write the sentences. Check your writing.

Jet streams are fast-moving air currents six to ten miles high in the atmosphere. There are two jet streams: the polar jet stream and the sub-tropical jet stream. The jet streams can affect weather patterns.

K

1. Overcurve, slant
2. Slant left
3. Slant right
4. Undercurve

The slant-left stroke ties at the dotted line and has a bit of a double curve to it. The wide slant-right angle gives the letter a good base. Trace and write the letter.

K K K

K K K

K

Trace and write the joinings and words.

Kl	Klondike	Ka	Kaylee	Ky	Kyle
Kl	Klondike	Ka	Kaylee	Ky	Kyle

Write the sentences. Check your writing.

Kilimanjaro is a mountain in

Tanzania, Africa. At 19,340 feet,

it is the highest mountain in

Africa. Kilimanjaro is an extinct

volcano with two snowcapped

peaks. Kilimanjaro has become a

favorite tourist attraction.

✔ CHECK-UP ☐ LINE QUALITY ☐ LETTER SPACING ☐ SIZE OF WRITING ☐ LETTER FORMS

Make a wide undercurve to allow room for the loop. Be sure to close the "nose" (overcurve-slide-back motion) part of the letter. Trace and write the letter.

k *k* *k*

k *k* *k*

k *k*

1. Undercurve
2. Slant
3. Overcurve
4. Slant, undercurve

Trace and write the joinings and words.

ke	*keen*	*kn*	*kneel*	*ki*	*kidney*
ke	*keen*	*kn*	*kneel*	*ki*	*kidney*

Write the sentences. Check your writing.

Wayne Gretzky is one of the greatest ice-hockey players of all time. He played in the National Hockey League for twenty-one years. Gretzky broke several records, including being the youngest person ever to be named Most Valuable Player in professional hockey.

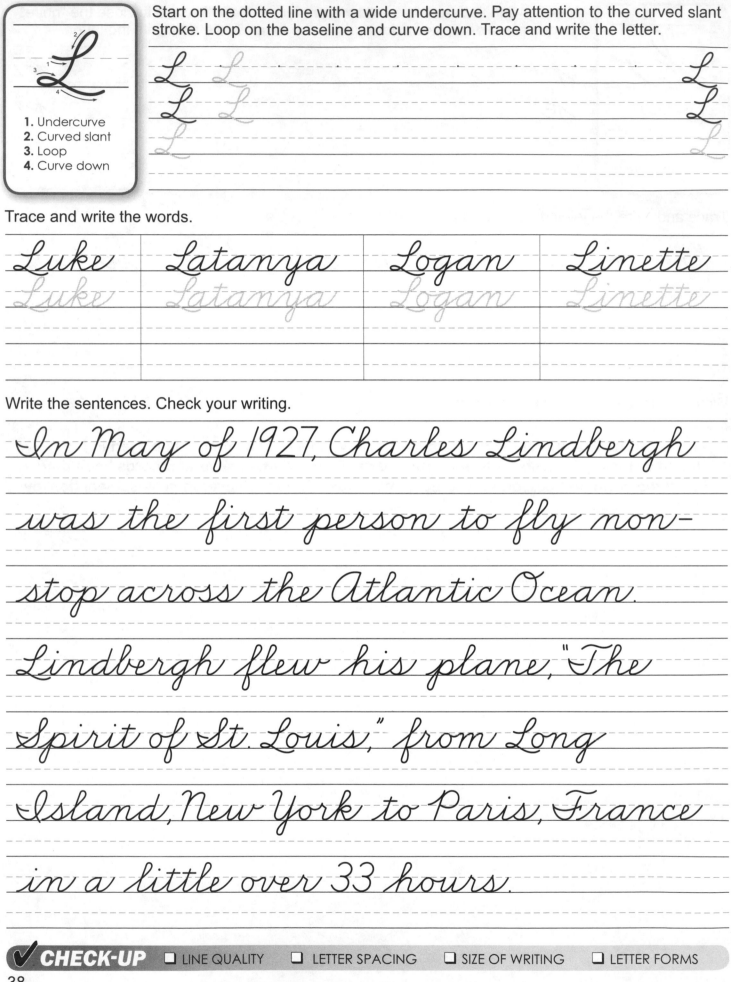

Start on the dotted line with a wide undercurve. Pay attention to the curved slant stroke. Loop on the baseline and curve down. Trace and write the letter.

1. Undercurve
2. Curved slant
3. Loop
4. Curve down

Trace and write the words.

| Luke | Latanya | Logan | Linette |

Write the sentences. Check your writing.

In May of 1927, Charles Lindbergh was the first person to fly non-stop across the Atlantic Ocean. Lindbergh flew his plane, "The Spirit of St. Louis," from Long Island, New York to Paris, France in a little over 33 hours.

Keep the loop open in this letter. Be sure you start with a wide undercurve. Pull the slant stroke to the baseline. Trace and write the letter.

l *l* *l* *l*
l *l* *l* *l*
l

1. Undercurve, curve back
2. Slant
3. Undercurve

Trace and write the joinings and words.

li	*lint*	*lo*	*loan*	*la*	*laboratory*
li	*lint*	*lo*	*loan*	*la*	*laboratory*

Write the sentences. Check your writing.

The Angel Falls in Venezuela, at 3,212 feet, are the tallest waterfalls in the world. The falls are named after James C. Angel who flew his plane over the falls and landed there in 1935 while looking for gold.

Odd and Even Numbers

An odd number is any number that cannot be divided evenly by 2.
Fill in the missing odd numbers in each series.

92 _____ 94 _____ 96 _____ 98 _____

144 _____ 146 _____ 148 _____ 150 _____

320 _____ 322 _____ 324 _____ 326 _____

56 _____ 58 _____ 60 _____ 62 _____

An even number is any number that can be divided evenly by 2.
Fill in the missing even numbers in each series.

91 _____ 93 _____ 95 _____ 97 _____

45 _____ 47 _____ 49 _____ 51 _____

271 _____ 273 _____ 275 _____ 277 _____

863 _____ 865 _____ 867 _____ 869 _____

Read the number words. Write the correct number.

1. **One hundred forty-three** 1._____

2. **Two hundred sixty-seven** 2._____

3. **Five hundred ninety-two** 3._____

4. **Seven hundred fifteen** 4._____

5. **Four hundred sixty-one** 5._____

6. **Seventy-four** 6._____

7. **Eight hundred thirty-three** 7._____

8. **Nine hundred forty-eight** 8._____

9. **Two thousand six hundred five** 9._____

✔ **CHECK-UP** ☐ NUMBER SIZE ☐ NUMBER SPACING ☐ SLANT OF NUMBERS ☐ NUMBER FORMS

40

Writing Cursive Numbers

Write the numbers in order from **smallest** to **largest**.

1,259
362
98
514
6,728
16
8,503
981
4,120
5,317

Write the numbers in order from **largest** to **smallest**.

10,947
653
1,421
9,854
32
198
83
79,265
2,814
46,370

Write the correct number for each of the questions below.

1. What year did Columbus discover America?

2. What year did the U.S. enter World War II?

3. What year was the Boston Tea Party?

4. How many miles away is the Sun?

5. How many miles away is the Moon?

6. How many inches are in a yard?

7. How many feet are in a mile?

8. How many miles is your school from your house?

9. What is the circumference of the Earth (in miles)?

1. _____

2. _____

3. _____

4. _____

5. _____

6. _____

7. _____

8. _____

9. _____

This letter has three overcurves. Be sure to retrace the first and second slant strokes. The three slant strokes are parallel. Trace and write the letter.

m m *m*
m m *m*
m

1. Overcurve, slant
2. Overcurve, slant
3. Overcurve, slant
4. Undercurve

Trace and write the joinings and words.

Ma	*Madison*	*Mi*	*Michael*	*Milly*
Ma	*Madison*	*Mi*	*Michael*	*Milly*

Write the sentences. Check your writing.

The Missouri River is the longest river in the United States. It flows from Montana to Missouri, where it joins the Mississippi River. The Mississippi River is the second longest river in the United States and flows from Minnesota to the Gulf of Mexico.

This letter also has three overcurves and three slant strokes. Be sure all three slant strokes are parallel. Trace and write the letter.

m *m* · · · · · · *m*
m *m* *m*
m

1. Overcurve, slant
2. Overcurve, slant
3. Overcurve, slant
4. Undercurve

Trace and write the joinings and words.

| ma | mascot | mi | mineral | mild |
| ma | mascot | mi | mineral | mild |

Write the sentences. Check your writing.

Magma is molten rock deep within the Earth's crust and upper mantle. Magma that is pushed through an erupting volcano is called lava. When magma or lava cools and hardens it forms igneous rock.

Begin with a short overcurve, then slant to the baseline. Retrace the slant stroke generously before making the second overcurve. Trace and write the letter.

1. Overcurve, slant
2. Overcurve, slant
3. Undercurve

n n n
n n n
n n n

Trace and write the joinings and words.

No Nora	Na Nashville	Ne Nelson
No Nora	Na Nashville	Ne Nelson

Next to each state, write the state's capital and the state. Example: **Harrisburg, Pennsylvania.**

Nebraska _____

Arizona _____

New Hampshire _____

New York _____

Tennessee _____

North Carolina _____

Oregon _____

Nevada _____

New Jersey _____

Indiana _____

Louisiana _____

New Mexico _____

North Dakota _____

✓ **CHECK-UP** ☐ LINE QUALITY ☐ LETTER SPACING ☐ SIZE OF WRITING ☐ LETTER FORMS

The two overcurves are wide and rounded. The two slant strokes should be parallel. The letter ends with a wide undercurve. Trace and write the letter.

n *n* *n* *n*

n *n* *n* *n*

n *n*

1. Overcurve, slant
2. Overcurve, slant
3. Undercurve

Trace and write the joinings and words.

no	notion	ne	nectar	network
no	notion	ne	nectar	network

Write the sentences. Check your writing.

The human body needs nutrients
to grow and function. Nutrients
are vitamins, minerals, proteins,
carbohydrates, and fats. Different
foods contain different nutrients, so
a well-balanced diet is important
to keep our bodies healthy.

Think of making a backward oval when you write this letter. After you close the oval, swing right forming the loop. Trace and write the letter.

O *O*

1. Backward oval (Close oval)
2. Loop

Trace and write the words.

Olivia *Oxford* *Oklahoma* *Ozzie*

Write the sentences. Check your writing.

Orangutans are apes that live in the forests of Borneo and Sumatra. They have very long arms, short bowed legs, a stout body, and long red hair. Orangutans move from tree to tree by grabbing branches. On the ground they walk on all fours.

This letter is also made with a backward oval. Be sure your oval has good slant. Close the oval and swing right. Trace and write the letter.

o

1. Backward oval (close oval)
2. Retrace, swing right

Trace and write the joinings and words.

ob	*obedient*	*oy*	*oyster*	*od*	*dodge*

Write the sentences. Check your writing.

Orangutans are an endangered species. Much of their natural habitat has been destroyed through logging and forest fires. Some people still illegally hunt orangutans, and baby orangutans are sometimes captured and sold.

Overcurve Joinings

The stroke used to join two letters greatly affects the legibility of your writing.

Overcurve to Undercurve

gl ye ju

1. The overcurve crosses at the baseline to form the lower loop of the letter.
2. The overcurve then changes direction as needed to properly form the next letter.

Any overcurve-ending letter that is joined to the lowercase cursive letters **b, e, f, h, i, j, k, l, p, r, s, t, u,** and **w** will join as shown in one of the examples. Trace and write the joinings. Write the words.

gl	gl	glue
ye	ye	yell
ju	ju	jug
zi	zi	zip

Overcurve to Downcurve

ga yo

1. The overcurve crosses at the baseline to form the lower loop of the letter.
2. The overcurve then continues up wide to properly form the next letter.

Any overcurve-ending letter that is joined to the lowercase cursive letters **a, d, g, q, o,** or **c** will join the same way as shown in the examples. Trace and write the joinings. Write the words.

ga	ga	gate
yo	yo	you
ja	ja	jail
zo	zo	zone

Overcurve to Overcurve

zz ym

1. The overcurve crosses at the baseline to form the lower loop of the letter.
2. The overcurve then continues up wide to properly form the next letter.

Any overcurve-ending letter that is joined to the letters **m, n, v, x, y,** or **z** will join the same way as shown in the examples. Trace and write the overcurve-to-overcurve joinings. Write the words.

gn	gn	gnat
ym	ym	gym
zz	zz	fuzz
gn	gn	align

Write the sentence.

Joining strokes influence your
slant and letter formations.

48

Overcurve Joinings

gh gh

je je

yo yo

za za

gi gi

ju ju

ye ye

zz zz

gl gl

jo jo

gs gs

ze ze

gy gy

ji ji

right

jewels

yolk

pizza

ginger

junk

yes

buzz

glee

jog

bugs

zebra

biology

jitter

Write the sentence.

The joining stroke determines

your spacing between letters.

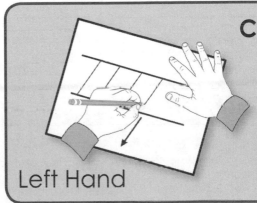

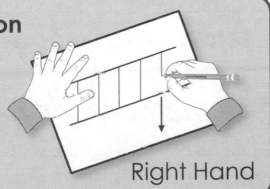

Cursive Paper Position

The position of your paper or book is important for maintaining consistent slant in your writing. It also helps with the overall legibility of your handwriting.

Left Hand

Right Hand

This letter begins with a wide undercurve. Pause at the top of the undercurve. Slant, retrace, curve forward, and tie at the dotted line. Trace and write the letter.

P

1. Undercurve
2. Slant
3. Curve forward, back, and tie

P P P
P P P
P

Trace and write the words.

Pierce	Phillipa	Poland	Panama
Pierce	Phillipa	Poland	Panama

Write the sentences. Check your writing.

Robert Peary, who was born in

Pennsylvania, was the first

explorer to reach the North Pole.

He failed to reach the North Pole

on two previous expeditions. He

was finally successful on his

third attempt in April of 1909.

p

1. Undercurve
2. Slant
3. Overcurve
4. Curve down
5. Undercurve

Trace and write the joinings and words.

pr	project	prevent	pa	panther

Write the sentences. Check your writing.

Many people confuse porpoises with dolphins. Both are mammals and are related to whales. However, porpoises are smaller than dolphins and rounder in shape. Porpoises also do not have a beak like dolphins do.

✔ **CHECK-UP** ❑ SLANT OF WRITING ❑ WORD SPACING ❑ LETTER FORMS ❑ JOININGS

Like the uppercase **O**, think of a backward oval when making this letter. After you close the oval, add the tail to the letter. Trace and write the letter.

1. Backward oval (Close oval)
2. Curve up, down

Q Q Q
Q Q Q
Q Q

Trace and write the words.

Qatar	Queensland	Quisha	Quinto
Qatar	Queensland	Quisha	Quinto

Pencil Position

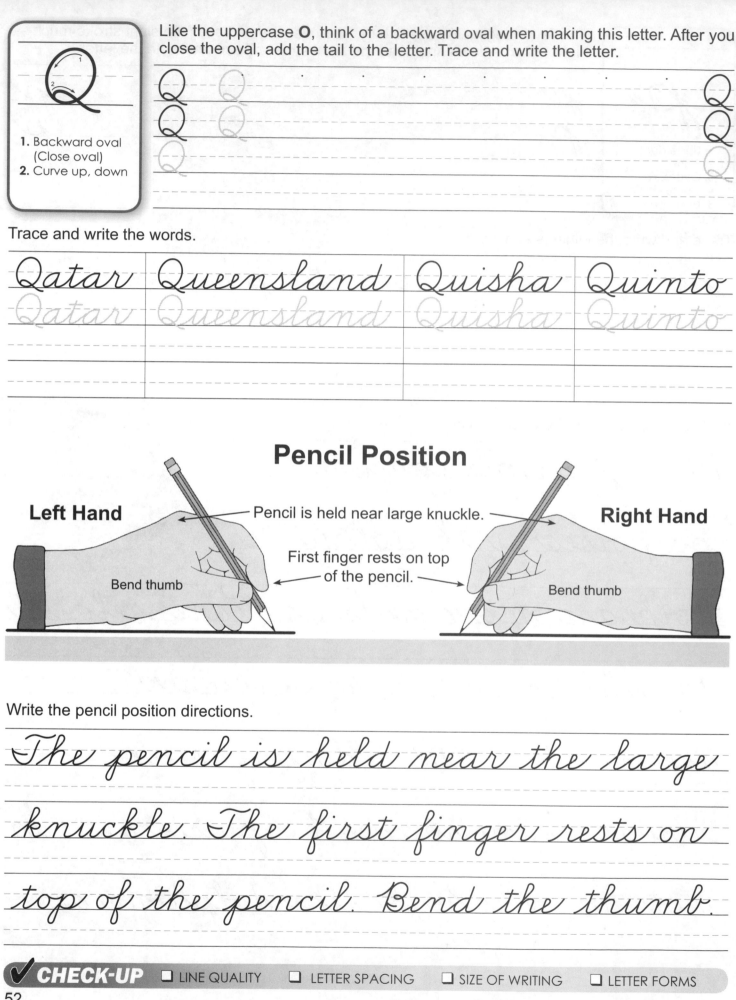

Left Hand Pencil is held near large knuckle. **Right Hand**

First finger rests on top of the pencil.

Bend thumb Bend thumb

Write the pencil position directions.

The pencil is held near the large knuckle. The first finger rests on top of the pencil. Bend the thumb.

This letter begins like the letter **g** and ends like the letter **f**. Be sure to close the downcurve-undercurve motion. Trace and write the letter.

q

1. Downcurve
2. Undercurve
3. Slant
4. Curve up, tie
5. Undercurve

Trace and write the joining and words.

| *qu* | *quarantine* | *bouquet* | *quail* |

Write the sentences. Check your writing.

An aqueduct is a structure that is used to carry water into cities or towns. The ancient Romans began building their first aqueducts in 312 B.C. to bring fresh water to the city. The Romans built a total of eleven aqueducts.

This letter begins with an undercurve-slant motion. Then retrace, curve forward, down, and tie. End with a slant right and undercurve. Trace and write the letter.

R R R

R R R

R R R

1. Undercurve
2. Slant
3. Curve forward
4. Slant right
5. Undercurve

Trace and write the joinings and words.

Ru	Rudy	Ra	Rachel	Re	Renato
Ru	Rudy	Ra	Rachel	Re	Renato

Write the sentences. Check your writing.

Hiram Rhoades Revels was born in

Fayetteville, North Carolina in 1822.

He was an ordained minister and

principal of a school for African

Americans. In 1870, Revels became

the first African American man

to be elected to Congress.

The undercurve extends to slightly above the dotted line. Retrace, slant right, slant left to the baseline and undercurve. Trace and write the letter.

1. Undercurve
2. Slant right
3. Slant
4. Undercurve

r r r ... *r*
r r r ... *r*
r r ... *r*

Trace and write the joinings and words.

re	rely	ri	ridiculous	ro	rove
re	rely	ri	ridiculous	ro	rove

Write the sentences. Check your writing.

Tropical rain forests are forests that receive large amounts of rainfall. On average, rain forests receive 67 to 100 inches of rain every year. Rain forests produce up to 40 percent of the oxygen in our atmosphere.

Undercurve Joinings

The stroke used to join two letters greatly affects the legibility of your writing.

Undercurve to Undercurve

ll te is

This is a very easy joining to make. The undercurve ending swings up naturally into the undercurve beginning of the next letter (see the arrow on each joining above).

The undercurve-ending letters join to the undercurve-beginning letters **b, e, f, h, i, j, k, l, p, r, s, t, u,** and **w** as shown in the examples in the box. Trace and write the joinings. Write the words.

ll ll wall
te te tent
is is fist
cr cr crab

Undercurve to Downcurve

so na

The undercurve ending swings up wide forming the top part of the next letter (see the arrows on each joining above). The downcurve of the second letter retraces part of the joining.

The undercurve-ending letters join to the downcurve-beginning letters **a, d, g, q, o,** and **c** as shown in the examples in the box. Trace and write the undercurve-to-downcurve joinings. Write the words.

ld ld told
so so soap
na na nail
ug ug rug

Undercurve to Overcurve

ly in

The undercurve ending swings up wide, then turns into the overcurve that begins the next letter (see the arrow on each joining above).

The undercurve-ending letters join to the overcurve-beginning letters **m, n, v, x, y,** and **z** as shown in the examples in the box. Trace and write the undercurve-to-overcurve joinings. Write the words.

ly ly only
in in pin
ev ev ever
ex ex text

Write the sentence. Check all of your undercurve joinings.

Eighteen lowercase cursive letters end with an undercurve.

Undercurve Joinings

Trace and write the joinings. Write the words. Check your joinings.

in	in	find
pe	pe	pebble
cy	cy	cycle
ee	ee	seem
dl	dl	idle
ta	ta	tail
fl	fl	flip
id	id	said
ly	ly	sadly
su	su	suite
qu	qu	quill
ht	ht	right
rr	rr	sorrow
ni	ni	nine

Write the sentence. Are all of your checkstroke joinings correct?

Fourteen lowercase cursive letters

begin with an undercurve.

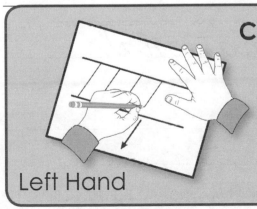

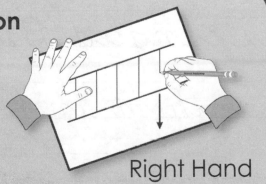

Cursive Paper Position

The position of your paper or book is important for maintaining consistent slant in your writing. It also helps with the overall legibility of your handwriting.

Left Hand

Right Hand

57

This letter begins with a very wide undercurve. Then curve back and down, crossing at the dotted line. Curve up and swing right. Trace and write the letter.

1. Undercurve, curve back
2. Curve down, curve up
3 Swing right

Trace and write the words.

Sabrina	Sergio	Somalia	Sweden

Write the sentences. Check your writing.

The Star-Spangled Banner is the national anthem of the United States. Francis Scott Key wrote the Star-Spangled Banner in 1814. Congress officially made the Star-Spangled Banner the national anthem in 1931.

✔ CHECK-UP ☐ LINE QUALITY ☐ LETTER SPACING ☐ SIZE OF WRITING ☐ LETTER FORMS

58

The undercurve beginning extends to slightly above the dotted line. Curve down and back to the undercurve. Finish with an undercurve. Trace and write the letter.

s s *s*

s s *s*

s

Trace and write the joinings and words.

sp	*splinter*	*si*	*size*	*sc*	*scholar*
sp	*splinter*	*si*	*size*	*sc*	*scholar*

Write the sentences. Check your writing.

The Sun is an average-sized star.

It is located at the center of our

solar system. It consists mostly of

hydrogen and helium. Scientists

believe that the Sun is about five

billion years old. The surface of

the Sun is about 11,000° Fahrenheit.

✔ **CHECK-UP** ☐ SLANT OF WRITING ☐ WORD SPACING ☐ LETTER FORMS ☐ JOININGS

Begin with a curved slant, then curve up, retrace, and swing right. Be sure to make the base of the letter wide. Trace and write the letter.

\mathcal{T} \mathcal{T} \mathcal{T}
\mathcal{T} \mathcal{T} \mathcal{T}
\mathcal{T} \mathcal{T}

1. Slant, curve up
2. Swing right
3. Curve up, down, up

Trace and write the words.

Thomas	Tacoma	Tina	Tokyo
Thomas	Tacoma	Tina	Tokyo

Write the sentences. Check your writing.

In 1767, the Townshend Acts, named after Charles Townshend, were passed by the British Parliament. The Townshend Acts were taxes on products brought to the colonies of America from England. In 1770, the Townshend Act taxes were repealed except for the tax on tea. This was called the Tea Act.

1. Undercurve
2. Slant
3. Undercurve
4. Cross

t t t
t t t
t

Trace and write the joinings and words.

th	thimble	tr	triumph	trial
th	thimble	tr	triumph	trial

Write the sentences. Check your writing.

In 1773, a group of patriots calling themselves the Sons of Liberty organized the Boston Tea Party to protest the Tea Act. The group, consisting of about 60 men, threw 342 crates of tea from the British cargo ships into Boston Harbor.

✔ CHECK-UP ❏ SLANT OF WRITING ❏ WORD SPACING ❏ LETTER FORMS ❏ JOININGS

61

Be sure to make the two slant strokes in this letter parallel. Keep the letter the proper width. Trace and write the letter.

U *U*

U

1. Overcurve, slant
2. Undercurve
3. Slant
4. Undercurve

Trace and write the joinings and words.

Un	*United States*	*Ur*	*Uruguay*

Write the sentences. Check your writing.

The United Nations (also referred to as the U.N.) is an international organization. Its purpose is to encourage peace and cooperation between countries throughout the world. The United Nations consists of 191 countries.

The three undercurves in this letter are very similar. The last undercurve is a bit wider. Both slant strokes should be parallel. Trace and write the letter.

u *u* · · · · · · · · · · · · · · *u*

u *u* *u*

u *u*

1. Undercurve
2. Slant, undercurve
3. Slant, undercurve

Trace and write the joinings and words.

| *ut* | *truth* | *un* | *universe* | *blunder* |
| *ut* | *truth* | *un* | *universe* | *blunder* |

Write the sentences. Check your writing.

Uranus is the seventh planet

from the Sun. It has an

unusual axis; it rotates on its

side, with its south pole pointing

towards the Earth. Uranus was

the first planet to be discovered

using a telescope.

✔ **CHECK-UP** ☐ SLANT OF WRITING ☐ WORD SPACING ☐ LETTER FORMS ☐ JOININGS

Write the sentences.

Between 1838 and 1839,
nearly 18,000 Cherokee
Indians were relocated west of
the Mississippi River. They were
taken from their homes and
forced to travel from Georgia to
what is now Oklahoma. Many
traveled over a thousand miles
on foot. About 4,000 Cherokee died
on the journey. The routes they
followed, and the relocation itself,
are known as the Trail of Tears.

Lewis and Clark

Meriwether Lewis and William Clark led an expedition to explore the western part of the United States. In 1804, when the expedition began, the west was still unknown territory. The expedition's goal was to find a water route across the country. They discovered new rivers and mountain ranges. Along the way they also discovered many new species of plants and animals. They traveled over 8,000 miles, from St. Louis, Missouri, to the coast of Oregon and back.

Write the sentences.

Keep the first slant stroke at the proper angle. Be sure your book is in the correct position for cursive writing. Trace and write the letter.

1. Overcurve, slant
2. Undercurve, curve forward

Trace and write the words.

Vietnam	Vanessa	Vermont	Vlad
Vietnam	Vanessa	Vermont	Vlad

Write the sentences. Check your writing.

William Henry Vanderbilt was

born in New Brunswick, N.J., in

1821. Vanderbilt became president

of the New York Central Railroad

in 1877. When he died in 1885,

Vanderbilt was the richest man

in the United States.

The third stroke is a sharp undercurve. Retrace the sharp undercurve slightly before you swing right with the ending. Trace and write the letter.

1. Overcurve
2. Slant
3. Undercurve
4. Swing right

Trace and write the joinings and words.

vo *vote* *vi* *violin* *ve* *vehicle*

Write the sentences. Check your writing.

Internal combustion engines power almost every vehicle today. Several variations of these engines work very well using a four-stroke approach called the "Otto Cycle." During the intake stroke, air and fuel enter through the intake valve. After the compression and combustion strokes, the exhaust leaves through the exhaust valve.

Begin this letter with the overcurve-slant motion. The last three strokes are undercurve, slant, and overcurve. Trace and write the letter.

\mathcal{W}

1. Overcurve, slant
2. Undercurve
3. Slant
4. Overcurve

\mathcal{W} \mathcal{W} ... \mathcal{W}

\mathcal{W} \mathcal{W} ... \mathcal{W}

\mathcal{W} ... \mathcal{W}

Trace and write the words.

Warsaw	Winona	Wyatt	Worcester
Warsaw	Winona	Wyatt	Worcester

Write the sentences. Check your writing.

Noah Webster wrote the

first American dictionary.

It took him more than 27 years

to complete; he finished the book

in 1828 at the age of 70. Webster's

dictionary contained over 70,000

words and definitions.

This letter is much like the lowercase **u**. In this letter, the last undercurve extends slightly above the dotted line; retrace and swing right. Trace and write the letter.

w *w* *w*

w *w* *w*

w *w*

1. Undercurve
2. Slant, undercurve
3. Slant, undercurve
4. Swing right

Trace and write the joinings and words.

wa	*wallet*	*wi*	*width*	*we*	*wept*
wa	*wallet*	*wi*	*width*	*we*	*wept*

Write the sentences. Check your writing.

How do you know whether to use the word "who" or "whom"? Use "whom" when it is the object of the sentence, as in this example: To whom are you speaking? Use "who" when it is the subject of the sentence: Who is speaking?

This letter consists of two slant strokes. The first slant stroke begins with an overcurve and ends with an undercurve. Trace and write the letter.

1. Overcurve, slant right, undercurve
2. Slant left

Trace and write the words.

| Xylina | Xavier | Xuxa | Xerxes |

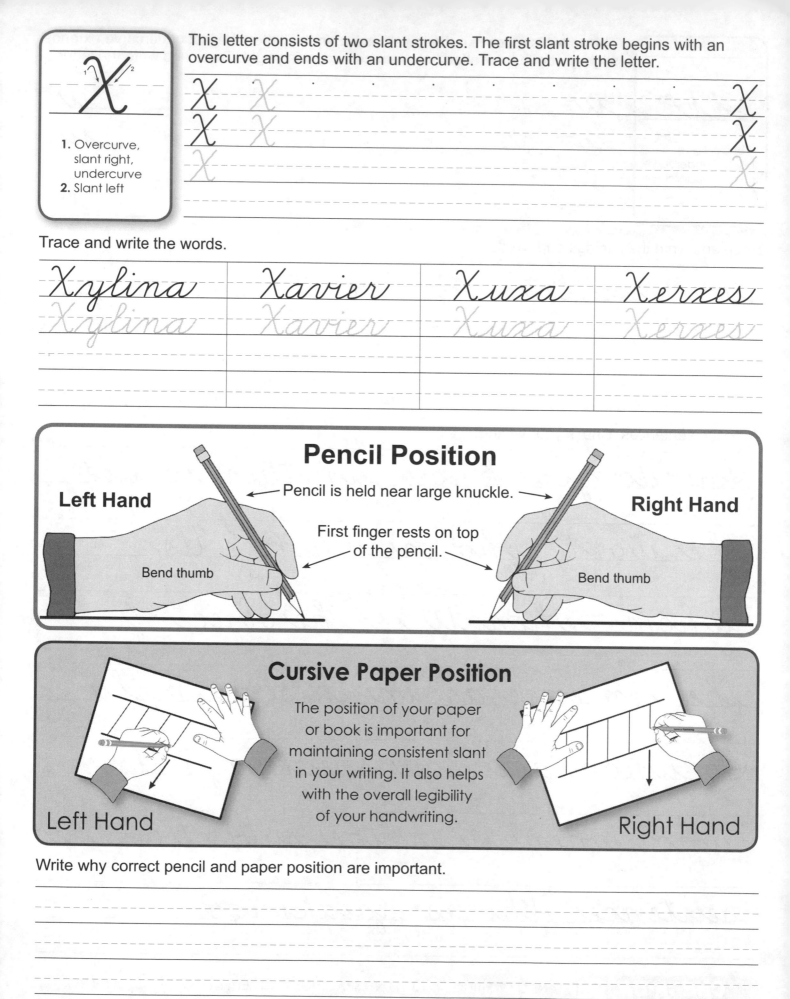

Pencil Position

Left Hand

Pencil is held near large knuckle.

First finger rests on top of the pencil.

Bend thumb

Right Hand

Bend thumb

Cursive Paper Position

The position of your paper or book is important for maintaining consistent slant in your writing. It also helps with the overall legibility of your handwriting.

Left Hand

Right Hand

Write why correct pencil and paper position are important.

Remember to make a good overcurve and pull the slant stroke to the baseline. Cross the letter with an upstroke. Trace and write the letter.

1. Overcurve, slant
2. Undercurve
3. Cross with an upstroke

x *x* *x*

x *x* *x*

x

Trace and write the joinings and words.

xa	*examination*	*xo*	*saxophone*
xa	*examination*	*xo*	*saxophone*

Write the sentences. Check your writing.

Excellent coordination is exactly

what xylophone players need to

be great. Most xylophones have a

series of wooden or metal bars

that are laid out like a keyboard

and then struck by the player

with a hard or soft mallet.

Photosynthesis

Write the sentences.

Photosynthesis is the process by which plants make food. Chlorophyll, the chemical in plants that gives leaves their green color, absorbs energy from the Sun. Plants then use this energy to convert water and carbon dioxide to sugar, which they use for food. This chemical reaction also produces O_2 (oxygen) molecules, which the plant releases into the air.

Carefully study the descending letters below.

Trace and write the letters. Write the words. Keep the lower loops open on the descending letters.

f f	*fever*
g g	*generous*
j j	*junior*
p p	*patio*
q q	*quick*
y y	*youth*
z z	*zebra*
Y Y	*Yukon*
Z Z	*Zachary*
J J	*July*

Write the sentences. Check your descending letters.

Peggy told Jay to pick only the

big purple grapes. They plan on

making grape jelly tonight.

Left Hand

Cursive Paper Position

The position of your paper or book is important for maintaining consistent slant in your writing. It also helps with the overall legibility of your handwriting.

Right Hand

✔ CHECK-UP ❑ SLANT OF WRITING ❑ WORD SPACING ❑ LETTER FORMS ❑ JOININGS

73

This letter begins like the uppercase **U**. The two slant strokes should be parallel. The overcurve ending crosses at the baseline. Trace and write the letter.

1. Overcurve, slant
2. Undercurve
3. Slant
4. Overcurve

Trace and write the joinings and words.

| Yv | Yvonne | Ye | Yemen | Ya | Yale |

Write the sentences. Check your writing.

New York was named after the Duke of York. It became the eleventh state on July 26, 1788. The capital of New York is Albany. New York City is the most populous city in the United States.

NEW YORK
Buffalo
Albany ★
New York City

Be sure you are holding your pencil correctly and your book is in the correct position. Keep the slant strokes parallel. Trace and write the letter.

y y y
y y y
y y

1. Overcurve
2. Slant
3. Undercurve
4. Slant
5. Overcurve

Trace and write the joinings and words.

yo	youth	ys	always	system

Write the sentences. Check your writing.

The pyramids of Egypt were

built thousands of years ago.

There are reported to be over 100

pyramids in Egypt. The Great

Pyramid of Khufu is the largest

pyramid ever built. It is made

from limestone and covers 13 acres.

Begin with a wide overcurve, then slant to the baseline. Retrace, curve up and down; the overcurve ending crosses near the baseline. Trace and write the letter.

1. Overcurve, slant
2. Curve down
3. Overcurve

Trace and write the joinings and words.

Ze	Zeke	Za	Zaire	Zu	Zurich

Write the sentences. Check your writing.

Pieter Zeeman was born in
Zonnemaire, the Netherlands, in
1865. He was a physicist who
discovered the Zeeman Effect. This
discovery provided astronomers
with a way to study the
magnetic fields of stars.

✓ **CHECK-UP** ❏ LINE QUALITY ❏ LETTER SPACING ❏ SIZE OF WRITING ❏ LETTER FORMS

Be sure the overcurve beginning is rounded and the slant stroke is pulled to the baseline. The overcurve crosses at the baseline. Trace and write the letter.

1. Overcurve
2. Slant
3. Curve down
4. Overcurve

Trace and write the joinings and words.

ze	citizen	zo	zone	zy	enzyme

Write the sentences. Check your writing.

The Grevy's zebra, the mountain zebra, and the plains zebra are three species of zebra all found in Africa. They love to graze. When full grown their size varies from 450 to 1000 pounds. In zoos zebras live for up to forty years.

OUR SOLAR SYSTEM

Write the sentences.

Our solar system consists of the Sun, nine planets, moons, the asteroid belt between Mars and Jupiter, and other smaller objects such as asteroids and comets.

Write the names of the planets in order from closest to the Sun to farthest away.

How many miles away from the Sun is the planet Earth? Write the number.

How many miles away from Earth is the planet Pluto? Write the number.

States of Matter

There are three states of matter:

solid, liquid, and gas. In a

gaseous state, the molecules of a

substance move quickly and are

the farthest apart.

Ice

Water

Steam

Write the sentences.

In a solid state, the molecules of a substance move slowly and are the closest together.
One of the few exceptions to this rule is water. Normally, a substance condenses (shrinks)
as it changes from a liquid to a solid. However, when water changes to ice, it expands.

The Gettysburg Address

Fourscore and seven years ago our fathers brought forth on this continent, a new nation, conceived in Liberty, and dedicated to the proposition that all men are created equal.

Now we are engaged in a great civil war, testing whether that nation, or any nation so conceived and so dedicated, can long endure.

Abraham Lincoln

Write the sentences from the Gettysburg Address.

✔ **CHECK-UP** ❑ LINE QUALITY ❑ LETTER SPACING ❑ SIZE OF WRITING ❑ LETTER FORMS